A Modern

Color
Photography

Minolta Corporation
Ramsey, New Jersey

Doubleday & Company
Garden City, New York

Photo Credits: All the photographs in this book were taken by the editorial staff unless otherwise credited. Cover: M. Heiberg; p. 3: F. Davis; p. 4: H. Weber

Minolta Corporation
Marketers to the Photographic Trade

Doubleday & Company, Inc.
Distributors to the Book Trade

This book and the other books in the Modern Photo Guide Series were created and produced by Avalon Communications, Inc. and The Photographic Book Co., Inc.

Library of Congress Catalog Card Number: 81-71037
ISBN: 0-385-18152-3

Cover and Book Design: Richard Liu
Typesetting: Com Com (Haddon Craftsmen, Inc.)
Printing and Binding: W. A. Krueger Company
Paper: Warren Webflo
Separations: Spectragraphic, Inc.

Manufactured in the United States of America
10 9 8 7 6 5 4 3 2 1

Contents

Technique Tips
Throughout the book this symbol indicates material that sup-
plements the text and which has been set off for your special
attention. You can apply the data and information in these
Technique Tips immediately to get better results in your color
photography.

Introduction

Color photography captures your world as you want it to look. Modern films are so versatile and accurate that you can make full color pictures everywhere, even without flash. This book explores the world of color showing you step by step how to get the very best results in color photography. You will learn how to get the most from your camera, as well as which films to choose for each situation.

Is negative or slide film best for you? What film speed do you need in bright light?...at night?...indoors? These important questions are answered fully. Getting precise exposures under even unusual conditions is covered fully in Chapter 3. Modern 35mm single-lens reflex cameras have excellent built-in meters. These give good average results but there are times when you should override the metering system. You can use your creative options by following special metering techniques shown in this book.

Fireworks are visually dramatic, but color is essential for capturing their full impact. Setting the shutter for a time exposure insures getting the full burst pattern—see Chapter 7. Photo: H. Petermann/Photogenesis.

A quiet understatement of the color in light-filled air is often the most effective way to convey the mood of a scene. Chapter 6 discusses many other ways to create mood with color. Photo: K. Phillips.

What are the most useful filters for color film? Which single filter will most dramatically improve outdoor pictures, especially on bright days? How can a filter on your lens improve color fidelity? Can filters be used over lights? These are some key questions which are answered.

Color photography requires more thought about light quality and film selection than black-and-white work. Matching color film with the correct light source is the first step toward superior color pictures. Your artistic sensitivity will be challenged, and technical aspects must be mastered. By combining technique, and art, your skill in working with color will improve. Adding light to your subject can often brighten colors and give you additional control.

Chapter 5 shows how reflectors and flash can improve your results. Even outdoors in full sun a simple reflector can make your portraits more attractive. We show how portable electronic flash units indoors increase your chance of capturing fast action or candid expressions.

Begin your photographic exploration with well-designed, modern equipment. The 35mm single-lens reflex camera, with an appropriate lens for your style of photography, is a highly versatile instrument. You can select from many internationally respected brands in different price ranges. Being able to compose directly through the active lens makes it easier to get precise results.

Successful color photographs often depend on careful placement of varying hues and skillful control of depth of field. A single lens reflex camera offers you full control of these creative techniques. With suitable equipment at hand you are ready to begin your exploration of color and learn to add impact to your color photographs.

Color surrounds you, but color preference is so personal, that to a great extent your approach to color photography will be subjective. You will subconsciously respond to elements with colors pleasing or interesting to you. How you capture these colors on film will influence the success of your photographs. As you learn to be sensitive to subtle variations in hue, you will improve your chances of creating memorable color pictures. You are surrounded by color, but to be a better photographer, you must truly *see* when you look. You can learn to see color artistically.

With experience a sensitive eye can visualize how a vivid color may gain intensity when it becomes the essential subject in a color photograph. For more on visualizing color effects, see Chapters 6 and 8. Photo: D. Gray.

1

The World of Color

Color has a strong influence on emotions. Understanding the emotional element in color photography can help you create stronger pictures, views that grab attention and stand out from the mass of common snapshots.

On bright days when colors vibrate and the light makes the world sparkle, we feel happier. In contrast, when the sun goes away, when days are gray and grim our emotions may be more somber, too. When colors are not bright, we must work harder to keep alert, to feel "up" and energetic. You can use this sensitivity to color in photographs as well.

Low Key and High Key. Cool colors, such as blue, green and brown, give "low key" effects which often make the viewer feel relaxed, calm or perhaps somewhat sad. Picture a misty landscape with fog rolling over a dark brown lake and masses of deep green evergreens in the distance. Such a view can give the viewer a sense of sadness or apprehension. Change the composition slightly by adding a flock of ducks flying by, or a fisherman's boat, and the view becomes more relaxing. The content works with your overall color to influence the photograph's final impact.

Black is a traditional color of mystery, sadness and grief, but it can also work with bright colors to direct attention where you want it. Black is a perfect background for colors you want to feature. Brilliant flowers stand out dramatically when composed against deep shadows or against black velvet. Portraits can gain power when color in the face and clothing dominate the composition, an effect easily accomplished when the subject is floating in a sea of black.

White helps even pastel colors draw attention. Use lots of white in your composition to give the photos an airy feeling and to help subjects appear light or even to float. When colors are pastel and the background white, you achieve a "high key" effect, often perfect for young children and nature studies.

Color and subject matter interact to create the emotional feel of a picture. The cool, misty blue complements the stillness of the water to increase the sense of quiet and calm. Photo: T. Tracy.

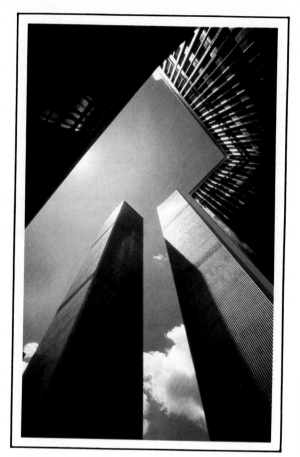

A truly selective eye knows how to use equipment such as an ultrawide-angle lens to isolate the subject and shows its qualities in an arresting way. Photo: J. Scheiber.

The Selective Eye

Starting to be aware of the contribution of color is a basic step toward increased sensitivity in your color photography. What colors are the most important in your subject matter? How can background selection influence the final impact of your color picture? Will a bright background harm or help the subject? Would a change of clothing color in a portrait photo improve the results? Will too much color hurt?

Your camera lens is an extension of your vision. When you use modern single lens reflex equipment, you capture on film only the colors and compositions desired. Selectivity plays an important role in creating powerful photos. When you select the appropriate lens, in combination with camera-to-subject distance, you have great control over perspective and the final impact of each photo. Take the photograph only when you have consciously reviewed the whole frame. Are all the elements of your composition in the best place for your photographic intent? Chapter 6 has details on how to use color for maximum effect in composition.

Technique Tip: Don't Show Too Much

One common fault with beginning photographers is a desire to show *everything* in one frame. Perhaps it is not a bad idea to get at least one extra wide view of every important subject, be it a city from a tall building, a scenic vista, or a group of friends at a party. But once you have captured a great expanse in a tiny frame, do the following:

1. Look for material within the subject that is especially interesting.
2. Search for a viewpoint that captures the main idea or emotion of the subject *without* showing the whole.
3. Change your subject-to-camera distance to see what this does to the composition.
4. Try different lenses, especially a moderate telephoto lens, to emphasize part of the subject, or a wide-angle lens, not to get more in the frame but to dramatize some part of the composition as you move closer.

All of these steps are designed to increase your powers of selection. Although film is relatively inexpensive, there is no reason to waste money. Learn to be selective in what you photograph. Modern cameras will usually give technically well-exposed photographs of anything in front of your lens, but you are after powerful photographs, not snapshots. Search for colors and other elements that make interesting compositions. This is an excellent way to train your artistic eye.

Move in close to eliminate unnecessary surroundings, and use a background that contrasts effectively with the subject's colors. Photo: A. Rakoczy.

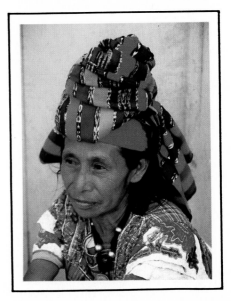

Nature's World

In nature, color is influenced by the weather. On bright overcast days the sun causes few reflections, and colors record on film with full saturation (depth and intensity). Professional photographers often spend thousands

Nature abounds with creatures that have vivid colors, including black-and-white. A tightly framed shot and a plain background often will set them off most effectively. Photo: O. Gjerde.

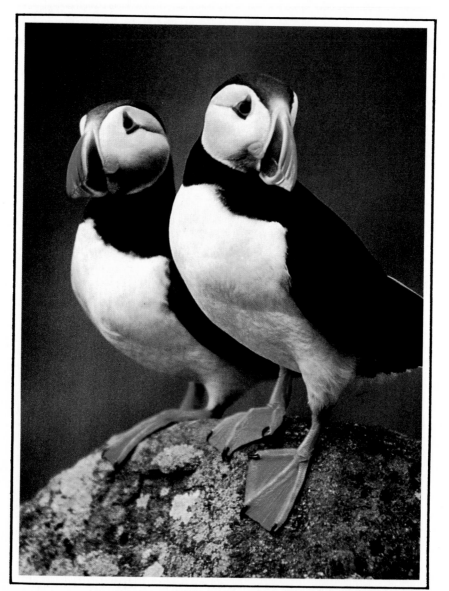

of dollars on special light diffusers and photographic umbrellas to get open shadows and a soft, wrap-around lighting effect. You will get the same impression in nature when the sun is hidden by a thin mist, such as that which occurs on cloudy-bright days.

In brilliant sun colors vibrate, but there may also be reflections that can degrade color pictures. In Chapter 4 you will find details about filters to use for the best results in bright sun. Sometimes you will want to show reflections, such as clouds or trees reflected on a pond or interesting patterns reflected on windows. Nature is a part of man's world, and offers splendid opportunities for beautiful photographs.

In scenic vistas, distant colors are grayed-out by atmospheric haze. Include brilliant colors in the foreground to contrast with the neutral tones and make the image truly a color picture. Photo: M. Fairchild.

Easier Than Black-and-White

In some ways color photography is less demanding than black-and-white photography because color itself can make a photograph more interesting, perhaps even artistically rewarding. Take a photograph of deep orange flowers against a soft out-of-focus green foliage background. You have a striking contrast between vibrant, warm colors and a gentle, relaxing hue. In such a composition soft lighting is appropriate and tight composition is important, but little else need be done to make the photo an artistic success.

Now translate this same subject into tones of gray. A black-and-white version of these flowers and foliage would be a more lifeless rendition of the colors that your eyes see as beautiful. Color film captures the drama perfectly; black-and-white film often reduces the impact. To render this same subject with impact in black and white would require strong directional lighting and perhaps a filter to make the orange flowers stand out from the soft green background.

Capturing color in nature is relatively simple with color film. Even if the photographer is not especially sensitive to lighting or composition, the colors alone will provide information about the subject. A field of wildflowers is interesting, at least for a quick glance, even if the color photo is not creative. In black and white, however, this same field of bright blooms becomes a sea of medium gray tones, only acceptable as a snapshot. Color adds life, separates subjects, makes capturing the real look of things on film less of a technical challenge.

Yet color photography makes its own demands. Although you may need to pay less attention to separation of subjects, you must devote more attention to the selection of film and the quality or color of light. With black-and-white panchromatic films you can take photographs on the same roll of film under many different light sources, with or without filters, and still get technically good results. In color this is not true.

When the colors are translated into black-and-white, many pictures lose graphic effectiveness and become mere records. Compare this with the color image, opposite.

Technique Tip: Natural Color

To improve your rendition of color in nature follow these steps:

1. Study subjects at all times of the day. The look of things in nature changes with the light. Will a different time of day improve the color fidelity as sunlight changes direction and hue?
2. Consider what kind of weather is best for the subjects you want to photograph.
3. Will the color be improved or made more dramatic by the use of a special filter?
4. What is the most appropriate angle from which to capture your subject? What do you want to feature?
5. How might using a reflector or flash unit influence your picture? Some creatures and woodland plants live in such contrasty light that some control of light and shadows almost always improves the color picture.

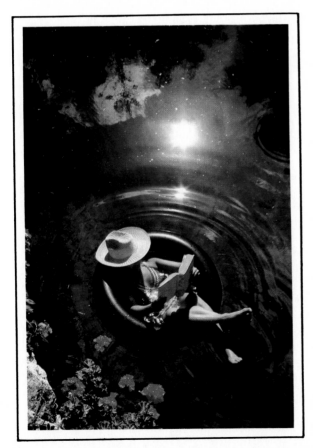

Local color, such as the flowers here, is often the element that transforms an acceptable black-and-white shot into a striking image. Photo: A. Moldvay/ Editorial Photo Services.

2

Color Films

What is the best color film for you? That question is best answered by another: How are you going to use your color photographs? Many photographers prefer to have all of their work in print form. They enjoy seeing every picture in small-size prints first, perhaps keeping the best in an album, then selecting a few superior views for further enlargements. For this purpose, they select a color *print* film, also called color negative film. Others prefer to project slides or plan on selling their color photographs; they select a color reversal film, also known as color *slide* film.

Excellent prints can be made from slides and you can also have good slides made from color negatives. Since this is true, why not choose just one film for general use? The main reason is cost and efficiency. Slide films are less expensive to process because you are paying only for developing and mounting, not for prints. Therefore, if you seldom want prints, or need the transparencies (slides) preferred by publications, it is less expensive to load your camera with slide film. If you prefer to have prints made from each roll, on the other hand, load your camera with a color negative film. Using the film best suited to your work means fewer processing steps and less expense.

How can you tell one film type from another? A general rule is that color negative (print) films end in the word "color" as with Kodacolor, Fujicolor, Sakuracolor. Slide, or transparency, films end in the word "chrome," as with Agfachrome, Ektachrome, Kodachrome, Fujichrome.

Since color is so subjective, you are the best judge of which film fits your subject. Some photographers prefer one type or brand's rendition of skin tones while others prefer another. But since print film is corrected for average skin tones during the final machine printing process in the lab, you will see less variation between brands than with slide films. The most variation occurs among films with different speed ratings.

Various color films use different dye sets to form their images; that means they will represent the same subject colors with subtle differences. Try a variety of films at first to discover which one suits your expressive taste best. This picture was made with Kodachrome film. Photo: H. Petermann/Photogenesis.

Speed and Grain

Film speed refers to a film's sensitivity to light. A high-speed film needs less light (exposure) than a slow-speed film to yield an acceptable negative. Film speed is expressed as an ISO/ASA number. The higher the number, the faster the film. Sometimes this rating number is used in the name of a film, such as Kodacolor 400. For many years the standard rating was prefixed by ASA for American Standards Association. Recently this has been changed to ISO for International Standards Organization. Fortunately, the actual rating numbers remain the same. In some European countries a DIN (Deutsche Industrie Norm) number is used. Modern 35mm SLR cameras with built-in meters have dials marked with the more popular ISO/ASA numbers.

Why not use a fast, very light-sensitive film all the time? The reason has to do with grain, the pattern of silver particles in the film. When the particles are small and close together, a negative is said to be fine-grained. You can make a big enlargement from a fine-grained negative without seeing a distracting grain pattern. As film speed is increased, the grain pattern also grows. Very fast films show more grain than medium or slow films. For the highest quality results, choose the slowest film compatible with the conditions under which you will work. The relationship of slow film speed to fine-grain images and of coarse grain with high film speed holds true in both slide and negative films.

You must choose a film on the basis of your aims, which may be different for each situation. The last part of this chapter is devoted to the factors you will consider when choosing films for each occasion.

The advantages of color negative film for many uses are clear: You get prints for easy viewing, gifts and albums; you have more latitude,

To avoid errors, read and use the important data printed on the film box.
Upper left: Number of exposures; Image size; Type of film. Lower left: Product code—ask for this at the photo store. (The dealer orders his stock by the catalog number.) Upper right: Kind of light emulsion is balanced for; Speed (ISO, ASA, DIN)—for camera or exposure meter. Center: Emulsion batch number—buy several boxes with the same number for consistent results roll-to-roll; Expiration date, month/year—expose and process film before this date for best results.

Technique Tip: Film Latitude

With color work *latitude* is very important. A film with wide latitude is able to yield acceptable results when given more or less exposure than is ideal. In practical terms, negative films have greater latitude than transparency (slide) films.

You can give negative films two stops more exposure than the ideal, but the resulting negative will still produce a print acceptable to most photographers. For example, if the ideal exposure is 1/125 sec. and f/8, but you take the photo at 1/125 sec. at f/4 you will still get a fairly good picture. Going the other way is also possible. If you take the picture at f/16 rather than the recommended f/8 you can still count on an acceptable image from medium speed negative film. A slide film has less latitude. Usually one stop over or one stop underexposure is as far as you can go with slide films and still expect an acceptable image.

greater freedom in exposing the film while still getting good results; full-color slides can be made from color negatives if you ever need them; prints can be made from color negatives easily, often at slightly less expense than if prints are made from slides.

With either slide or negative film, when a bright subject is against a black background, take an exposure reading only from the subject. Move in close if necessary to eliminate the background from the metering area of your camera's exposure control system. Photo: H. Weber.

Slide Films

Why do some photographers never use negative color film? There are several reasons. The most important for many is cost. Having all of your photographs printed, even in small sizes, is expensive. Taking slides, then just printing those few that you really want enlarged, is less expensive than routinely sending every roll for developing and prints.

A second important reason why many photographers use slide film is for publication purposes. Publishers generally prefer transparencies for reproduction. Finally, photographers who take photographs for teaching, lectures or for viewing by large groups, need slides for *projection*. Showing your photographs to a group is easy if the pictures are in slide form, but difficult if they are prints.

Format. The most generally accepted slide format around the world is 35mm. These slides are mounted in square plastic or cardboard holders measuring 2″ × 2″. The actual slide area in popular 35mm size is 24 × 36mm, but some cameras using 126 cartridges yield 24 × 24mm slides although the outside slide mount size is the same.

Choosing the most convenient format is important with slide film because the slides will often be projected. Since the 2″ × 2″ mount is so universally accepted and since many popular projectors are designed to accept this size slide, you will have an easy time with 35mm. If you use 110 slide film, consider having it mounted in 2″ × 2″ mounts for easy projection in standard 35mm slide projectors.

Using a larger slide film format is practical if your work seldom requires projection or if you are willing to use a larger, less common type slide projector. Most schools, public institutions, libraries, business audiovisual departments, etc., have only 35mm slide projectors on hand. If you take 2¼ × 2¼ slides, you will need a special projector.

Actual image area of the three most popular film formats.
120 film: 6 × 6cm (2¼″ × 2¼″).
135 film: 24 × 36mm (1″ × 1½″).
110 film: 13 × 17mm (½″ × ⁵/8).

Slides smaller than 35mm are not as popular because the small slides offer less quality in enlargements. Of course, small slides are not as easy to view or to project at a large size either.

Slide Characteristics. Slide film has more detail in shadows and highlights than can be captured on printing paper. When you have slides printed, expect that the contrast will increase slightly. For example, a projected slide will show some detail in dark shadow areas, but in a print from the slide these shadows may be totally black. In contrast, the highlights in a slide may have some detail, but in a print they may be less visible. Chapter 9 has some hints about getting the best results from slides when they are printed.

Exposure. Since slide films have less latitude than negative films you should use more care in exposing them. A Kodak Neutral Test Card (gray card), as explained in Chapter 3, is useful for getting the most precise exposure with varied subjects. In general, it is best to meter for highlights with slide films and for shadow areas with negative films.

This means that if your camera has a built-in meter, be sure that the most active part of the metering area is aimed at the brighter parts of your subject. These highlights, where you still want detail, should come out in the slide with color, not just pure white. If your metering technique favors these light areas, your slides will have highlight detail. If your metering technique favors the shadows, the dark areas, the resulting slides will have detail in the shadows but highlights with little or no color. (Negative color film is better able to capture both shadow details and highlight color than the slide film.)

To freeze sports action you must use a fast shutter speed. That means you will need a fast film—ISO/ASA 200 or higher—for proper exposure, even in bright sunlight. Photo: P. J. Bereswill.

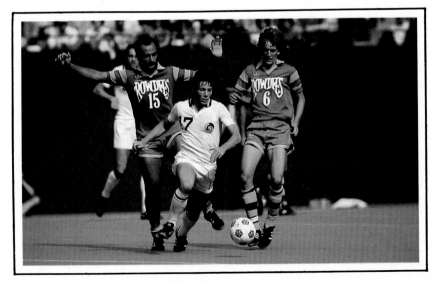

Sometimes you may want a print immediately. Having an instant color print is great fun at parties, picnics, sporting events or other occasions. Professional photographers use instant print films to get a quick idea of how their final photographs will look. Even with constant light sources or modeling lamps with electronic flash, it is helpful to study final effects on a reference print.

Instant color films come in two basic types, determined by how they are developed. The most common type is a film that yields a quick print directly after the photograph is taken. These films include the Kodak instant print film and the Polaroid SX-70 films. These films develop outside of the camera as you watch.

The second sort of instant color print film comes as a pack to fit different camera bodies or special film holders designed for larger format cameras. The film is exposed, then pulled from the camera or film holder for development outside of the camera between a paper and chemical sandwich. After a specific time period, usually 60 seconds at average room temperature, you pull the print away from the chemical/paper combination. Polaroid Polacolor films are an example of this sort.

Polaroid makes several types of instant color print films, designed for specific applications. The SX-70 type cameras take only the develop-in-front-of-you types, but other cameras and film holders accept various packs. Polaroid film packs are available with several types of print film. The most useful for general photography is the 3¼" × 3⅜" pack with type 88 Polacolor 2, and the 3¼" x 4¼" pack with type 108 Polacolor 2 Film. Film packs from Kodak for the Kodak instant cameras give 10 exposures per pack as do the Polaroid SX-70 packs.

When larger format instant print films are loaded into special holders for professional cameras, they yield images of different sizes, depending upon the design of the cameras in which they are exposed. Some studio photographers are even using 8" × 10" Polaroid!

Duplicates from Instant Print Film. How can you get extra prints from an instant color print if there is no negative or slide? Fortunately both Kodak and Polaroid offer duplicate print services for their films. Some private color labs will also make duplicate prints, slides, negatives, and enlargements from instant color prints. Kodak and Polaroid offer enlargements from their instant films at competitive prices.

If you have a single-lens reflex camera that will focus close, you can take photographs of the instant color prints, to yield slides or black-and-white or color negatives. See the Print Copying section in Chapter 8 for the technique to follow.

A mass of a single color often requires a contrasting accent such as the figure of the gardener to make an effective picture. Photo: M. Fairchild.

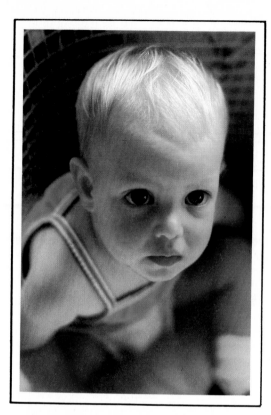

Skin tone rendition is a critical test of color balance. To get beautiful results like this, use a film exactly matched to the light on the subject; here it was daylight. Photo: J. Peppler.

Color Balance

In Chapter 4 we discuss how to use filters for maximum color quality. It is always wise to use the fewest filters possible and you will find that color quality is best when your film choice matches the quality (color) of light falling on your subject. If you shoot in sunlight or use electronic flash, choose a daylight-balanced color film. If you plan on using photofloods or tungsten-halogen (quartz) lights, choose a film balanced for tungsten light.

Both daylight-balanced and tungsten-balanced slide films are readily available. In small sizes, up to 35mm, all presently-available color negative film is daylight-balanced. To use these color negative films with tungsten lights, put a conversion filter on your camera lens (see Chapter 4). Color negative film in size 120 (for 2¼ x 2¼ or larger negatives) is available in a tungsten type as Vericolor II Professional Film Type L.

If you like color negative film choose a fast film such as Kodacolor 400 to take photos in mixed lighting, such as reading lamps mixed with daylight, or in low lighting, as is found at rock concerts, stage shows, etc. This film is designed to give pleasing results even when exposed under unusual lighting combinations, although it is balanced for daylight. Presently all instant print films are daylight-balanced.

Technique Tip: Film Speed Guidelines

A general rule is to choose the slowest (lowest ISO/ASA) film possible for each situation. Here are some guidelines for deciding how fast a film speed you need.

Use Slow Film When:
1. You have abundant light.
2. Want to make big enlargements.
3. Need the very best color fidelity.
4. The subject is not moving or will be stopped by flash.

Use Medium Speed Film When:
1. Maximum flexibility is needed in choosing f-stops and shutter speeds *without* accepting large grain.
2. You will have adequate light to use the shutter speed and f-stop combinations you want.
3. Your camera will not accept ultra-fast films because it has a limited metering system.

Use Fast Film When:
1. You must photograph under low-light conditions.
2. Subjects must be stopped with a fast shutter speed.
3. The smallest f-stops are required for maximum depth of field but you must *also* use a moderate to fast shutter.
4. Large enlargements are not required and/or a grain pattern is not objectionable.

The soft light of an overcast day can give excellent results with even a slow (ISO/ASA 25) color film. Photo: T. Tracy.

3

Exposure

Getting perfect exposures is easy with modern cameras and precision meters. You must remember to adjust the ISO/ASA setting correctly for the speed of the film just loaded. An advanced 35mm single-lens reflex camera is a versatile tool, but it must be programmed for the film you choose before the metering system can be expected to deliver the best average exposures. Simple cameras with cartridge-load films are adjusted automatically by the cartridge when it is put into the camera, but 35mm film magazines have no camera programming functions. You must manually set the film speed on the camera meter or accessory hand-held meter. Knowing the correct ISO/ASA rating is easy because most manufacturers mark it both on the package and the magazine of film itself.

If you happen to have a 110 or 126 film cartridge-load camera be sure to check the instruction book for the types of film it will accept. Some older cameras accept only slow and medium-speed films; they were not made to accept high-speed films.

Why not use a fast, very light-sensitive film all the time? The reason has to do with grain, the pattern of silver particles in the film. When the particles are small and close together, a negative is said to be fine-grained. You can make a big enlargement from a fine-grained negative without seeing a distracting grain pattern. As film speed is increased, the grain pattern also grows. Very fast films show more grain than medium or slow films. For the highest quality results, choose the slowest film compatible with the conditions under which you will work. The relationship of slow film speed to fine-grain images and of coarse grain with high film speed holds true in both slide and negative films.

Sun lighted subjects have a long brightness range. To get a proper exposure reading of a scene like this, aim your camera so the sky occupies only about one-third of the area that the meter takes in. Check your camera instructions—some meters cover the whole frame, others only the central portion. Some automatic cameras will let you lock in the proper exposure reading while you adjust the framing to the composition you want, with other cameras you will need to use the manual mode of operation. Photo: P. Bereswill.

Average Exposure

Film speed ratings and standard processing will produce pleasing results when the film is exposed at the recommended ISO/ASA with the great majority of adequately lighted subjects. That is, the speed and the processing assume a normal or average subject and exposure. In slides and in prints from negative films you can obtain a full range of tones, from very light to dark. However, correct exposure is rather critical with slide films. Negative films have more room for over- or underexposure before the pictures suffer.

For example, a negative color film can be overexposed or underexposed by two f-stops and still yield prints of acceptable quality. The *best* quality usually results when the film is exposed precisely, according to the meter reading. The degree to which a film can be over- or underexposed but still give acceptable pictures is called latitude. Negative films have more latitude than slide films; your exposure precision must be greater with slide films if you expect maximum quality.

Proper exposure for skin brightness is essential in pictures of people. Be sure the face fills the metering area when you take an exposure reading. Photo: B. Krist.

Overexposure produces results that are too light; colors look weak.

Underexposure produces a dark picture with heavy or muddy colors.

Slide film shows noticeable differences with exposure variations. Compare the results above with the proper exposure at the right. To insure the best results, make additional shots with more and less exposure. See Chapter 3—and your camera instructions—for ways to "bracket" exposure. Photo: C. Child.

Two mechanical parts of your camera control the exposure. One is the size of the lens opening, the aperture or *f*-stop. How the aperture is adjusted, what *f*-stop you use, determines how much light comes into the camera. The second camera control over exposure is the shutter speed.

The *f*-stop and shutter speed work together with mathematical precision. In most cases if you choose fast shutter speeds you will need relatively large lens openings.

When the light falls upon the film for a very short time, as with fast shutter speeds, the light must be bright, more intense; hence the need for a large *f*-stop to let in more light. The opposite occurs with slow shutter speeds. When the light will hit the film for a relatively long time it can be less bright but still produce the correct exposure. A small *f*-stop reduces the brightness.

Exposure can be determined precisely by a light meter. The meter senses the amount of light, relates it to the film speed, and indicates a series of speeds and *f*-stop combinations, all of which will produce the same average exposure. For example, *f*/11 at 1/15 sec., *f*/5.6 at 1/60 sec., and *f*/2 at 1/500 sec. will all produce the same exposure. You can see the equivalent exposure combinations on most meter dials, or you can easily count them out on the chart given here.

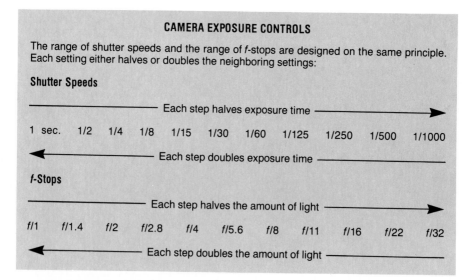

CAMERA EXPOSURE CONTROLS

The range of shutter speeds and the range of *f*-stops are designed on the same principle. Each setting either halves or doubles the neighboring settings:

Shutter Speeds

Each step halves exposure time ⟶

| 1 sec. | 1/2 | 1/4 | 1/8 | 1/15 | 1/30 | 1/60 | 1/125 | 1/250 | 1/500 | 1/1000 |

⟵ Each step doubles exposure time

***f*-Stops**

Each step halves the amount of light ⟶

| *f*/1 | *f*/1.4 | *f*/2 | *f*/2.8 | *f*/4 | *f*/5.6 | *f*/8 | *f*/11 | *f*/16 | *f*/22 | *f*/32 |

⟵ Each step doubles the amount of light

Automatic Exposure Control. Cameras with automatic exposure control features contain built-in meters that let you choose one exposure factor while the camera automatically chooses the other factor, based on the meter's response to the subject brightness. An *aperture - preferred* (aperture-priority) camera lets you choose the *f*-stop while it automatically

selects the matching shutter speed. A *shutter-preferred* (priority) camera lets you choose the speed while it takes care of setting the lens aperture.

Depth-of-Field Control. If you want maximum sharpness near and far—called depth of field—use the smallest possible *f*-stop. But keep in mind the slow shutter speed that will require.

When you want the depth of field to be shallow, perhaps to put a distracting background well out of focus so it becomes a pleasing blur of color, use a wide aperture with an appropriately fast shutter speed.

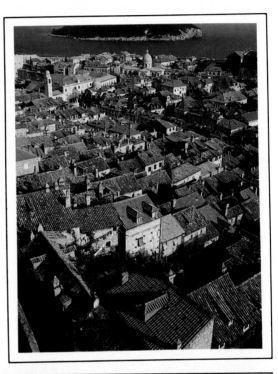

(Right) The smallest aperture on any lens produces the greatest depth of field, or area of sharpness. How much that depth actually is depends on the focal length of the lens and the distance at which it is focused. Photo: T. Tracy. (Below) A large aperture minimizes depth of field. This is useful for throwing distracting background and foreground elements out of focus. It directs attention to the main subject by separating it from the surroundings. Photo: N. deGregory.

Using Your Camera Meter

The built-in meters in modern single-lens reflex cameras read the light from behind the lens and the meter reacts to the light *reflected from* the subject; this is called reflected-light metering. Hand-held meters can read either the light *reflected from* the subject or the light *falling on* the subject; the latter is called incident-light metering. Some devices are sold that clip on the front of a lens, thus turning the camera's meter into an incident-light meter. When taking an incident-light reading, the meter is held at the *subject* position, pointed back toward where the camera will be. This technique ignores the actual subject brightness. Instead, an incident-light meter collects the light falling on the subject, and uses that to provide an average exposure recommendation.

In contrast, a reflected-light reading—the type you will usually take with your built-in camera meter—is directly influenced by the subject brightness because the meter is pointed at the subject. The basic techniques for making and using reflected light meter readings are given in the box. In general, reflected-light readings give excellent results with negative as well as slide films, both black-and-white and color. Incident-light readings are most useful for determining color slide film exposures.

When subjects have average reflectance the reflected-light meter will suggest a correct average exposure and the colors will be accurate. However, if the subject has very high or very low reflectance, the meter suggestions, or automatic exposure, will not be pleasing.

For reflected-light readings with this handheld meter the light sensitive cell is pointed directly at the subject. When an incident-light reading is desired, the translucent dome is positioned over the light sensitve cell. The meter is then pointed toward the camera from the subject position.

Technique Tip: Reflected-Light Metering Techniques

1. Set the meter to the ISO/ASA speed of the film.
2. Point the meter (or camera lens, for a built-in meter) at the subject from the camera direction. Outdoors, tilt down so that the sky occupies less than one-third of the area being read.
3. For *broad area subjects,* such as landscapes, and subjects with many areas of different brightness or color: just as the overall meter reading indicates. This technique is best for the majority of fully lighted subjects.
4. For *single large area subjects,* with a small amount of background: expose the film as indicated by a meter reading taken from the most important color area.
5. For *portraits:* Take a reading from the face. Expose the film as indicated by meter.

A Meter Trick. There is an easy way to get an average reflected-light meter reading for a white or black subject, or a subject against a great expanse that is much brighter or darker than what you want to feature, or a subject that is too small to fill the meter reading area. The trick is to take the reading from a substitute subject.

The best substitute subject is a standard gray card (the Kodak Neutral Test Card, available in photo stores). If you do not have a gray card, you can use the palm of your hand instead. Proceed as follows.

1. Place the gray card at the subject position, or in the same kind of light that is falling on the subject.
2. Compose your picture of the subject and focus sharply. Then approach the gray card, without refocusing, until it fills most of the camera viewfinder (or hand-meter reading area).
3. Adjust the camera exposure controls according to the meter reading from the gray card. If your camera is working on automatic, be sure to lock in the gray card meter reading.
4. Remove the gray card, frame your photograph again, and make the exposure.
5. If you take the meter reading from the palm of your hand, held in the same light as the subject, give *one stop more* exposure than the meter indicates.

The gray card is a substitute subject of average (18 percent) reflectance. But your hand is one stop more reflective and will fool the meter into thinking there is that much more light. That is why you must adjust exposure from the palm reading.

Good exposure is not a mystical subject. It is simply a matter of determining what average exposure should be, and then thinking about what is important in the picture. That will tell you how to adjust the exposure.

When your composition includes a wide range of brightnesses, adjust exposure to favor the most important part of the photograph. For example, a person with dark skin against a bright white sand beach or sparkling water will need more exposure than the surroundings if you want full detail in the face. That means the beach and water will be slightly overexposed when you provide the ideal exposure for your human subject. On the

Of course, you must know how to adjust exposure accurately. Study your camera instruction book carefully. Some cameras have meter positions that program variations. For example, if you know that a general meter reading or automatic camera exposure will give one stop too little light, adjust the built-in meter to give a one-stop increase. This feature is usually written on the meter dial as +1. To get one stop less exposure than the average meter reading, use the −1 position.

Overriding The Fully Automatic Camera. If your camera is fully automatic, without any way to override the meter or hold in (lock) a meter reading taken from a gray card or close-up from the subject, then proceed as follows:

1. Decide how much more or less you want to expose the film. For example, one stop *more* exposure for people in sunlighted snow.
2. Set the meter ISO/ASA dial to a speed setting one-half *lower* than the actual loaded film calls for. If you are using Kodacolor II with a usual rating of 100, but decide that the meter will give an exposure one stop too little—too dark—then set the meter dial for ISO/ASA 50. This adjustment will make the camera do what you want.
3. To get *less* exposure, set the meter for a *higher* film speed. Double the ISO/ASA number to get one stop less exposure.
4. For two-stop changes, multiply the original film speed by four for less exposure, or divide it by four for more exposure.
5. Remember to reset the meter for the usual rating when you are ready to photograph subjects of average reflectance or usual conditions again.

The most expressive exposure is not always what the camera meter suggests. Here the meter indicated proper exposure for the interior, but the photographer decided to override that and expose for the outdoor scene. The meter-indicated exposure would have washed out the exterior; the photographer realized the interior would work effectively as a silhouette. Photo: B. Docktor.

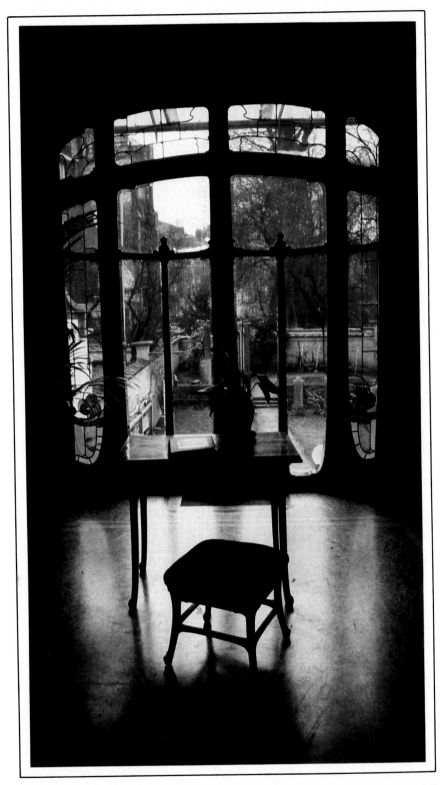

Meter Readings and Light Directions

Your meter readings will vary depending upon the direction of the light. For example, the face of a person facing away from the light source will require more exposure than if the person were facing toward the source assuming that the same amount of detail is desired in both cases. Certain adjustments must thus be made to ensure proper exposure.

Frontlight. For front-illuminated subjects of average reflectance, simply set the camera for the exposure indicated by the meter lights or needle, using the normal film rating. If the subject is very dark or very light, adjust the suggested exposure by one-half to one stop or use a gray card to obtain the average exposure reading.

Backlight. Take a meter reading off the subject from close up, so the camera is not influenced by the backlight, or open the lens one to two *f*-stops more than the meter suggests for a subject in the same location but frontlighted. For example, you are outdoors on a bright day and a frontlighted subject needs 1/125 sec. at *f*/11, but you want to take a photograph with the sun *behind* the subject (backlighting). Take the exposure at 1/125 opened up one stop to *f*/8 for light subjects, or two stops to *f*/5.6 for dark subjects.

Backlighted subjects require more exposure for detail in shadowed areas than an overall meter reading taken from a distance would suggest. Open the lens one or two f-stops from such a reading, or take a close-up reading of the main subject without including the backlight. Photo: M. Fairchild.

For color slides of sidelighted subjects, base exposure on the lighter areas. With negative films, adjust exposure to favor the darker areas for more shadow detail; highlight detail can be printed-in. Photo: T. Tracy.

Sidelight. For sidelighting, expose for the most important part of the composition. With negative film favor the shadows when setting your exposure, with slide film favor the bright areas. If you do not care about having detail in the shadows, just set meter readings from the bright portions. If there is too much contrast between the light and dark areas, so that the dark areas lose more detail than you desire, then add light to the shadows with reflectors. Outdoors, using a large white card or a sheet of aluminum foil as a reflector is much easier than trying to fill shadows with electronic flash.

39

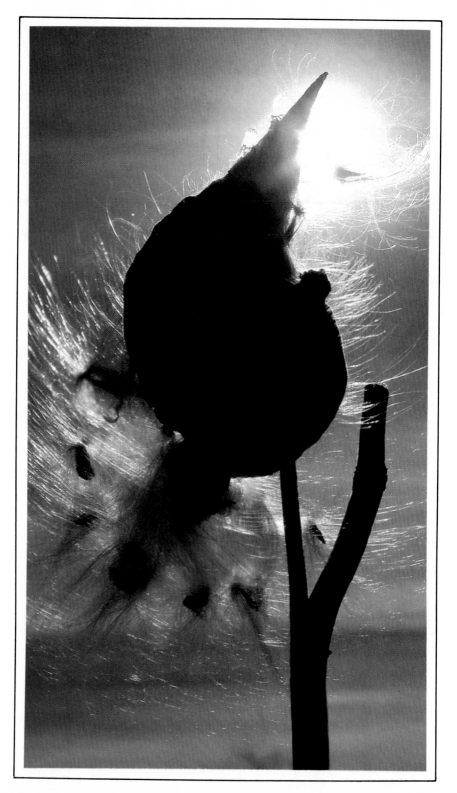

Low-Light Situations. Besides the unaverage situations created by subjects of very high or very low reflectance, you may have to photograph under unusual conditions such as at night. For powerful nighttime exposures with dark backgrounds but well-exposed lights, buildings, and windows, or for people on a stage lighted with spotlights, etc.,try to get reflected-light meter readings taken when the subject almost fills the frame. If you can't get close, you could change to a telephoto lens to take a reading, then change back to the other lens to actually take the picture. If this is impossible consult the folder that comes packed with high-speed film.

For example, Ektachrome 200, Ektachrome 400, and Kodacolor 400 films are so often used under these unusual situations that Kodak includes exposure recommendations with the film. The folder with ISO/ASA 400 film suggests exposures for 15 existing-light situations, such as neon signs, night football, stage shows, floodlighted buildings, etc.

Sunrises and Sunsets. For the best color saturation, take meter readings from the colored sky. (If you plan on photographing the sun before it is low on the horizon, or after it has risen, do not look through your finder directly at the sun. Focus the lens at infinity and simply point the camera toward the sun.) Meter readings taken off the just-rising sun or a fully colored setting sun close to the horizon will give excellent color, with some detail in the other parts of the picture, full detail in the sky.

If you want more detail in the land portion of your photograph, meter with the sky only partially in the frame, or open up one to two stops beyond suggested exposures taken from the sky. As with all unusual exposure situations, you should bracket exposures.

Metering for Silhouettes. To create a silhouette arrange your subject against a very light or even pure white background. Often the sky will do if it is much brighter than the subject. Take a meter reading off the *background* and expose as suggested by the meter. Since the subject is two or more stops darker than the background you will get a silhouette. Unintentional silhouettes are likely to occur if your meter reads a very bright background and automatically gives an exposure based on the bright areas rather than the subject. Experiment with silhouettes against the sunset for dramatic color pictures.

To get a full silhouette, ignore the subject brightness. Take a meter reading from the bright background and expose accordingly; the subject will go black. Photo: C. M. Fitch.

Bracketing Exposures

Professional photographers are in the habit of taking a photograph at the suggested meter reading plus additional frames with less exposure and more exposure. This is called bracketing. You should do the same, when the situation is unusual or when you are photographing something that cannot be captured again. Sometimes one of the frames that you took lighter or darker will be more pleasing than the meter-suggested average exposure. With negative film, bracket by a full *f*-stop or shutter speed; with slide film bracket by one-half stop or shutter speed.

For example, if you are using Kodacolor II print film and the meter suggests 1/60 at *f*/11, take the suggested exposure. Then take another at 1/60 at *f*/8 (one stop more) and a third at 1/60 at *f*/16 (one stop less). If you are using a slide film such as Kodachrome 64 and the meter says 1/60 sec. at *f*/8, take the suggested exposure. Then take a second at 1/60 at *f*/6, and a third at 1/60 at *f*/10. You will not find these half-stop positions listed on the lens, but they occur halfway between the marked *f*-stops on either side of *f*/8. Some lens controls click into place at the halfway positions. For very important subjects on slide film bracket two half-stop steps in each direction: for example, at *f*/8, *f*/6, *f*/5.6, and at *f*/9 and *f*/11.

Bracketing color exposures is inexpensive insurance. Make controlled departures from the basic metered exposure to be sure of getting good results under difficult conditions. Bracketing also compensates for differences in film and equipment, and lets you interpret subjects to your own tastes. Photo: J. Child.

Push Processing

Color films can be exposed at higher than normal ratings if they are later given special processing. This technique is called push processing. There may be times that a recommended ISO/ASA rating is just not fast enough for what you want to do. In this case consider taking the *whole roll* at a specific higher rating. Eastman Kodak labs will give Extra Special Processing (ESP service) to their Ektachrome films exposed for ratings they specify.

These Kodak ESP ratings are stated with the data sheet that comes packed with the films, and are presently double the usual ISO/ASA. Thus Ektachrome 160 Tungsten film can be used at ISO/ASA 320, Ektachrome 200 at 400 and Ektachrome 400 at ISO/ASA 800. This service is offered by Kodak Labs for 35mm and 120 size films only. Private labs offer processing at these and other unusual ratings. The ESP processing from Kodak Labs is slightly more expensive then normal processing since they make an additional charge. Whenever rating color film at an ISO/ASA different from the recommended standard, be sure to expose the whole roll at a single rating, then be sure that the processing lab knows the rating used.

Pushing color film results in slightly less color fidelity plus some increase in grain and contrast, but at the standard Kodak ESP ratings the quality is acceptable to most photographers. Kodachrome is *not* given ESP service by Kodak.

Pushing color film allow you to shoot under low light conditions, but the results may show more contrast and grain than you would like. In a high-contrast situation, slight underexposure is better than pushing a film. Here, increased saturation from underexposure enhances the feeling of the dark street. Photo: B. Sastre.

4

Color Quality

Color quality depends upon good equipment and the appropriate film exposed correctly. But assuming that your camera is working correctly and that you have a good lens, what more can you do to get the best possible results from color film?

A most important step is to give a precise match of the color of the light source to the film you are using. To do this, you must know the color temperature of each light source and match the film to it or use the right filter. Color films are designed to be used with light of a specific color temperature, measured in Kelvins (abbreviated K).

The color temperature rating, in Kelvins, can be found on film boxes and in the data sheets that are packed with most film. Daylight-balanced film is formulated to be used with light sources having a temperature of 5500K. This kind of light will be found outdoors from mid-morning until about 3 p.m. under average conditions. At high altitudes, especially under clear blue skies, the Kelvin rating is much higher and the light color is very blue. Late in the day and under some polluted-air conditions the daylight color will be more orange and have a lower Kelvin rating.

Colors in the blue range (higher Kelvin numbers) are often called cool, while those in the orange-red range (lower Kelvin numbers) are referred to as warm. Some photographers prefer a slightly warm look, especially for photographs of people. If you use daylight-balanced color film with sunlight under average conditions, from mid-morning until early afternoon, you will be pleased with the resulting color quality.

When daylight film is used with electronic flash, you will also get good results because the modern electronic flash tubes (and blue flash bulbs) are designed to give the correct color for daylight-balanced film. If you use daylight film with fluorescent lamps, the results will look greenish unless you use a filter.

Most floodlighting on buildings and monuments is warmer in color balance than daylight. Use a tungsten-type film for best results. Remember that long exposures need extra exposure from what the meter suggests; take extra shots to be sure. Photo: T. Tracy.

Filters for Fluorescent Lights and Color Conversion

Since fluorescent light tubes differ in their color temperature, you will obtain only a general correction from the single filters designed for exposing color film under fluorescent lighting. For a more precise correction method, see Eastman Kodak publications with details about specific color-compensating filter combinations to be used with each type of fluorescent lamp. For example in the Kodak Photo Book AB-1 "Filters and Lens Attachments" there are 6 common fluorescent lamp types listed along with various color compensating filters to use for maximum correction. For example, with daylight film exposed under warm white fluorescent lamps, one must add a 60C (cyan) filter and a 30M (magenta) filter combination, which in turn requires 1⅔-stop more exposure.

An easier approach, quite acceptable for general photography, is to use a single screw-on filter made to compensate for the greenish tinge given color photographs by most fluorescent lamps. Of course our eyes do not see these subtle variations in color temperature but the film does. Using a filter will help pictures to look normal. Many manufacturers have filters to help you get good color under fluorescent lamps. If you use electronic flash in a room lit by fluorescents, the flash will usually overpower the green tinge. An FL-D filter is for use with daylight color film; an FL-B filter is for use with tungsten (Type B) film.

Filters that make major changes to alter the color of light to match a specific film balance are known as color conversion filters. These are made by various manufacturers, but their characteristics are similar. The numbers for these conversion filters are standard and appear in the film directions printed by film manufacturers.

These filters used on the camera lens affect all the light reaching your film and can convert the light source to the correct color temperature for your film. Combinations of filters may be required in some situations. Professionals who often expose color film under variable light conditions on location use a color temperature meter. The color temperature meter reads Kelvin rating of the light and has dials which recommend specific conversion filters to get the best results. However these meters are expensive and not required for the vast number of situations.

Daylight Kelvin Fluorescents. A few fluorescent lamps, a kind often used in art schools, fabric stores and by horticulturists who grow plants indoors under lights, have a color temperature very close to that of daylight. These unusual fluorescent lamps fit regular household fluorescent fixtures, so you can put them in your home, office, or studio if you want to have true daylight-colored light. Daylight-balanced film exposed under these fluorescents, which are around 5000K, will give good results, although the color is not as ideal as with sunlight or electronic flash.

Use the filters indicated in the accompanying chart to match the light source to the film color balance.

COLOR CONVERSION FILTERS

Film type	Light		
	Daylight; Elec. flash	Tungsten 3200K	Tungsten 3400K
Daylight	None	80A	80B
Tungsten (Type B)	85B	None	81A
Type A	85	82A	None

To add a touch of warmth to a subject photographed under clear blue skies, use a No. 81A filter. To get a fairly strong blue cast, use an 80B filter. Photos: P. Morash.

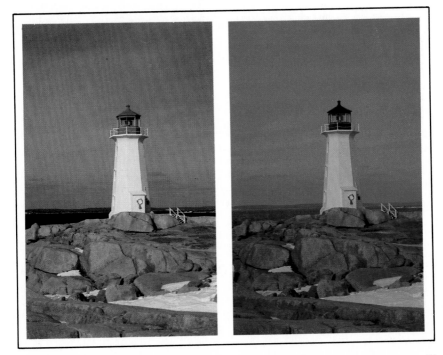

Skylight and Ultraviolet Filters

Your lens should have a protective filter if there is any chance that the lens element may get scratched or dirty. Constant cleaning, even when done carefully with lens tissue, will eventually cause slight scratching on the glass and damage lens coatings. Many photographers protect the actual lens element from damage by leaving on a skylight (light pink) filter or ultraviolet (light yellow, almost clear) filter. Both the skylight and standard ultraviolet (UV) filters are so lightly tinted that they require no additional exposure. Of course, with cameras that have behind-the-lens light metering, you do not have to figure additional exposure for filters. A protective filter that needed extra exposure compensation would not be so universally accepted.

A UV filter is especially valuable for distant landscapes and pictures taken at high altitudes. Excess ultraviolet in these situations can cause detail-degrading haze and a bluish cast if not filtered out. Photo: M. Fairchild.

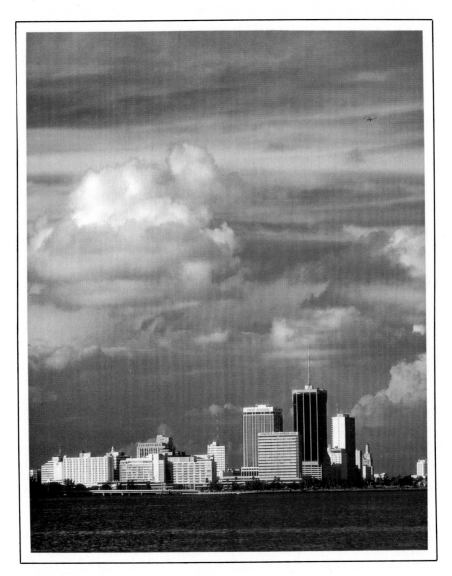

A skylight filter, which has a slightly pink color, helps eliminate the blue tinge.

A skylight filter will generally improve color in photographs taken outdoors, especially in open shade. The UV filter, sometimes called a haze filter, will give slightly more detail in distant views where ultraviolet light emphasizes haze. If you mainly photograph people, choose the skylight filter as your standard protection. If you frequently take distant landscape photographs choose the ultraviolet or haze filter as your standard protective filter. Get one of these universal protective filters for each of your lenses. Take the filter off only when you are going to add other filters or attachments. Having several filters or attachments on front of a lens is likely to cause dark corners (vignetting) and a reduction in sharpness.

A polarizing filter eliminates glare from water, glass, and other non-metallic reflective surfaces. Without a polarizing filter, this aerial view of Bonaire in the Caribbean would have shown no differentiation in the colors of the water. Photo: B. Sastre.

Polarizing Filters

Another universally useful filter is the polarizer. This dark gray filter will reduce or eliminate much of the glare caused by bright sunlight or by artificial light indoors. The polarizer is also the only filter that will let you make the sky bluer without changing other colors. By eliminating or reducing the polarized light that causes poor color saturation, the polarizer permits true colors to come through.

Much reflected sunlight comes to your camera as a white or silver light. When the polarizer eliminates this reflected light, true colors can register on your film. The polarizer is the best filter for improving color quality under bright conditions outdoors. It is especially useful for landscape work, travel photography, and getting fully saturated colors.

You will find polarizers most effective when the light source is at a right angle to your subject. When the sun is directly overhead, as at noon, the polarizer has only a mild effect, but when the sun is lower your polarizer will darken the sky dramatically.

With a single lens reflex you can pre-judge the effects of your polarizer. Look through the lens as you turn the polarizer in its mount. (Polarizers are made to turn once they are screwed into your lens.) There may be times when only a slight effect is desired. For example, it might be possible to remove all reflections from a lake or stream, but the

photograph would look lifeless. You can adjust the polarizer to reduce but not completely eliminate the reflections.

A polarizer filter absorbs some light, so exposure must be increased, usually by about 1½ f-stops. Your camera will probably provide the required exposure increase without special adjustment if it has behind-the-lens metering.

When used to eliminate reflections you will find the polarizer most effective at a 30 to 40 degree angle from the reflective surface. Since the polarizer also removes reflected light from haze it is useful for distant views and landscapes too. Reflections off a subject's eyeglasses can often be reduced by using a polarizer.

One caution with the polarizer: if you plan on photographing through the windows of commercial planes check the results through your lens first. Most modern jet windows are made from a plastic material that produces a rainbow effect if seen through a polarizer. You may like this multicolored effect and use it as an artistic device, but it is not part of the normal color to be seen outside the plane.

5

Adding Light

What is the best way to add light to a subject? The answer depends on what light is already available, and what you want to accomplish with the light.

If you want to *reduce contrast* by filling in dark shadows formed by a constant light source such as the sun or a lamp, then a reflector is the best way to add light in the darker portion of your composition. The advantage of using reflectors is that you see what they are doing before you take the picture, in contrast to what happens when you fire a flash unit. Only larger, relatively expensive electronic flash units have model/focusing lights that let you preview where the light will fall. An electronic flash burst is so fast you cannot see its effect. This is why using a reflector for fill-light is often better than using a flash.

In color photography you must use a neutrally colored surface, such as white or silver, as a reflector. If you bounce light from a colored surface the resulting light will carry a color tint. For example, a light blue card used to bounce sunlight into the shadows will produce unattractive blue in the shadow areas. Silver surfaces are the most versatile for reflecting light. Reflector material offered for photographic use comes in flexible sheets with a tough plastic base. Various textures are available to change the quality of reflected light.

A smooth, shiny surface will form a mirror-like reflection. Mirror-surface reflectors are useful for lighting small areas or for beaming light a long distance. A nature photographer might use one to direct a beam of sunlight into a clump of flowers or across tree bark. But highly reflective mirror surfaces are not the best for gentle fill-light needed in portraiture. For pleasing light on people, choose a pebbled- or textured-surface silver reflector material.

Light bounced from a large white reflector softened and diffused the shadows for this delicate portrait of a young woman. A second light was used to lighten the background. Photo: R. Farber.

Reflectors are usually placed opposite the light source to add fill light on the unlighted side of a subject. They can be angled to "fine-tune" their effects.

Reflectors

Reflector Materials. Suitability of reflector material depends upon several factors. In black-and-white photography any reflective material that bounces light where you want it is suitable. A ceiling or wall can be used as a bounce surface, but here we are considering *portable* reflectors that you can position freely. The best approach is to choose a reflector material that will serve both color and black-and-white work.

One company offers more than ten different reflection media. Many photographic stores stock some of these materials. A very useful type is a thin, foil-like material that offers a featherweight pebbled reflection surface on a tough tear-resistant base that folds easily and compactly. This material can be hung, pasted, tacked or formed into any shape you wish. One handy type comes with a silver color on one side and a gold color on the other. You might use the silver side for true colors and the gold side when you want skin tones to look richer, as though your model has a tan.

Besides the featherweight material you can also buy a slightly tougher fabric in patterns to make the reflection soft, super soft, or hard.

Cloth Reflectors. Some photographic reflectors are made from fabrics coated with reflective material. The fabrics fit over lightweight metal frames which in turn can be fastened to stands. One of the advantages of these reflectors is that the fabrics can be folded to fit into small cases while the stands can be collapsed and fitted into heavy-duty plastic carrying cases. In addition, electronic flash units or lamps can be fastened to the stands, then pointed at the reflector for bounce lighting. You can vary the fabrics to change the quality of reflected light. A super silver surface gives sharp light and distinct shadows, while a plain silver surface provides a softer light that is ideal for portraits; a gold fabric warms the light, soft white gives very flat fill, and a translucent fabric lets you aim a light directly *through* it for a diffused effect. The translucent type is also useful to direct sun outdoors.

Umbrellas. Light bounced from a light-colored or white umbrella gives a soft wraparound effect with very open shadows. When the umbrella is placed to one side of the subject the light is directional enough to show texture and cause some shadows on the opposite side. As the umbrella is moved toward the subject, providing reflected light from the front of the camera position, the shadows become weaker and the light flatter.

Umbrellas made for photographic applications come in different surfaces, similar to those mentioned above for fabric reflectors. Frosted translucent umbrellas are used to diffuse direct (unbounced) light from flash, lamps, or the sun.

Umbrella reflectors may be used in several ways. One method is to fire the flash directly into the umbrella which bounces diffused light back onto the subject. The umbrella can also be used as an ordinary reflector, opposite the light source, to provide soft fill. Umbrellas come in various sizes and are usually used when broad "wraparound" illumination is required.

Sunlight plus Flash

Flash Fill. Even when the sun is bright you may want to add light in the shadow areas that occur when the sun strikes the subject at an angle. When a reflector is impractical to use or not available, you can use a portable electronic flash unit for this purpose. The technique of blending electronic flash with available sunlight is called flash fill. To do this proceed as follows:

1. Determine the *f*-stop required for correct exposure in the daylight, using the proper shutter speed required for electronic flash sync. This is usually between 1/60 and 1/125 sec. in 35 mm SLR cameras. As an example, assume that the flash sync speed is 1/60 sec. and that exposure in the sun at 1/60 is *f*/8. Set your camera for this exposure.
2. Now adjust your flash unit to give about one stop less light. Modern electronic flash units often have variable output settings, usually at one-fourth, one-half, and full power. This is a very helpful feature for efficient fill-flash outdoors. The dial on such units shows which power setting to use for full exposure at various flash-to-subject distance and *f*-stop combinations. Using a *lower* power setting will reduce the flash exposure.
3. In this case let us assume you are 2 meters (6½ ft.) from the subject. The dial on the flash says that at full power with the film you are using, the flash exposure should be *f*/8, the same as for the available light. If you use this full power setting the flash will equal

To get the proper ratio of fill-light to natural light requires careful calculations as described in the text.

Technique Tip: Reducing the Brightness of Non-Variable Flash

If your flash unit does not have variable power, you can still reduce its light for flash fill. There are two simple ways to do this:

Cover the flash head with a layer of white cloth such as a pocket handkerchief. Each layer of cloth reduces the light about one stop in intensity.

OR

Move the flash unit farther from the subject. First, using the flash dial or instruction sheet, determine the correct flash-to-subject distance for normal (full) exposure. Multiply that by 1.4 to get the new distance for a one-stop reduction in flash exposure. If you are using negative film, you can simply move camera and flash together to the new distance, and specify the desired cropping and framing of the subject when you have an enlarged print made. If you are using slide film, you will have to keep the camera at the position that gives the desired composition and move only the flash unit. This means you will need a sync connecting cord long enough to reach the camera, and human or mechanical assistance for holding the flash unit in position.

the brightness of the sunlight, giving a flat, artificial look, without any shadows or modeling. To avoid this, adjust the power ratio to half, thus giving enough light to expose the film at f/5.6.

4. Compose and take the photograph, using the meter-suggested camera exposure of f/8 at 1/60 sec. (sunlight reading). Because the flash is used at f/5.6, a power *weaker* than the available sunlight exposure, it will fill in or lighten the dark shadows without washing them out or overpowering the natural light.

Flash as the Main Light Source. To expose pictures mainly by electronic flash, with little effect from the available light, be sure that the flash provides light at least two f-stops brighter than the available light exposure.

If you use flash on a moving subject when the available light is equal to that produced by the flash, you are likely to get a double image.

Since correct balancing of electronic flash with sunlight is often difficult, you may find that reflectors are an easier approach to adding light. However, when there is no or very little available light, as at night, then flash is a great advantage.

Flash exposures outside at night require wider lens apertures than indoor shots because there are no walls or ceilings to reflect spill light onto the subject. You will need to test to determine an effective guide number for such work. If you are in a hurry, try giving two stops more exposure than you would indoors and bracket around that estimate. Photo: M. Fairchild.

Flash Outdoors at Night

The exposure dial on electronic flash units and the guide numbers given in instruction booklets are based on using the flash indoors. When you use flash outside at night there is no other light to add to the exposure and, more importantly, there are no ceilings or walls to reflect some of the flash onto the subject. You may well find that non-automatic flash exposures

determined by dial or guide number are one to two *f*-stops less than ideal when you work outdoors at night. The best way to learn how to deal with this situation is by practical test.

Take some test frames at a fixed distance between light and subject but at several different *f*-stops. Be sure to record the *f*-stop used for each frame. Then examine the processed results to determine a new "nighttime" guide number. Since guide numbers are correlated with flash-to-subject distance, you will find it easiest to do the test with the subject 3 meters (10 ft.) from the flash.

1. At night outdoors arrange a subject 3 meters from the flash. Usually the flash will be on the camera so you can read the distance directly from the lens focusing distance scale.

2. Find the recommended guide number for the film you are using. For this example we will say that the guide number with your unit is 80 for an ISO/ASA 64 film. That means an *f*/8 lens opening at 10 feet (10 feet divided into the guide number of 80). The shutter is set at the electronic sync speed.

3. Take a series of photographs from 3 meters at *f*-stops of *f*/4.5, *f*/5.6, *f*/8, *f*/11. You do not need to test smaller *f*-stops because you will need more, not less, exposure at night outdoors.

4. Study the pictures when they are processed. Choose the frame that looks best to you in terms of color saturation and general exposure. Multiply the *f*-number used for that frame by the flash-to-subject distance to get your new nighttime guide number. If the *f*/8 exposure looks best to you then the recommended guide number (80) is suitable. However, if the *f*/5.6 exposure looks best (very likely in this night situation outdoors), then the effective guide number for your unit outside at night is 5.6 x 10 = 56.

Note that when electronic flash is used as the only source of light the fast burst will determine the actual speed at which the frame is exposed. This is why even small portable electronic flash units can stop fast action. Even if the subject moves during the exposure it will only be shown for a brief fraction of a second as the flash goes off. For example, one popular portable flash unit fires at 1/1000 sec. on manual and up to 1/50,000 sec. in some auto models—more than enough to "freeze" moving subjects and eliminate any chance of camera shake showing.

One important point to remember is that the light from a single on-camera flash unit will only carry for a limited distance. Attempts to photograph large or distant subjects with on-camera flash will not be successful. Night street scenes, distant buildings or landscapes, and similar subjects must be photographed with long exposures or with fairly eleborate multiple-flash slave units (if the subject is small enough). Otherwise, you are wasting your film and your effort.

Bounce flash illumination, shown at left, is closer to soft, overcast outdoors light than the more common direct flash (photo at right). For bounce flash portraits, place the subject near a white wall and aim the flash at the wall just in front of and above the subject's head. Use a white card opposite the flash to reflect some light into the shadows. Photos: J. Scheiber.

Flash Indoors

Inside, flash can bounce off nearby surfaces, helping to fill in shadows and adding some light to the overall exposure. Rooms with low white ceilings and light-colored walls often give better results for indoor flash photos than rooms with high or dark ceilings.

Direct flash gives a crisp light with distinct dark shadows. If you prefer softer light with more open shadows, aim the flash at the wall opposite your subject, or at the ceiling several feet in front of the subject. When photographing people, be sure not to bounce the light off the ceiling directly above the subject because this causes dark shadows under the eyes.

For pleasing bounce flash illumination off a white wall, position the person 0.6–0.9 meters (2–3 ft.) away from the wall. Remember that with color film you should only bounce light from white or silver surfaces; light bounced off colored surfaces comes back tinted.

Bouncing the flash reduces its intensity. For manual-mode exposures you will need from ½ to 1½ stops additional exposure, depending upon the room size and the total flash-to-subject distance, (that is, the combined distance from the flash to the bounce surface to the subject). Shooting a test-and-experiment roll of film is the best way to learn about controlling bounce flash. Automatic flash units will give proper exposures when the light sensor is *at the camera position* and is aimed *at the subject,* not at the bounce-light ceiling or wall.

Multiple Flash

When using multiple flash units only one need be attached to the sync socket or hot shoe of your camera. To fire the additional units equip each one with an automatic slave switch (also called a remote trigger). These small devices see the light when the main unit goes off and cause the remote flash units to fire simultaneously. An example of using several flash units for a portrait would include a main flash aimed at the person from near the camera, a second flash for fill light on the opposite side (either farther away or at lower power for about one stop less light than the main flash), and a third flash aimed at the subject from behind and above to illuminate the hair. Some photographers also like to aim a light at the background.

If your subject is small enough, you can almost illuminate evenly with a single flash unit. In this case the lower right portion of the mask is in shadow.

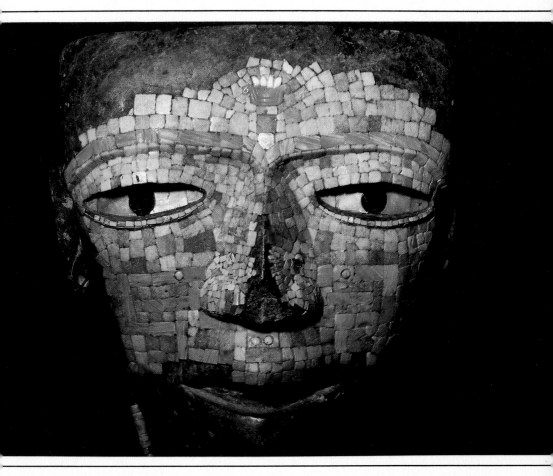

Filtering Light Sources

When adding light from flash or tungsten lamps, you can change the artificial light color with filters designed for the lights used. Some portable electronic flash units offer colored plastic filters as a regular optional accessory. Some of these filters are similar enough in effect to camera screw-in light converting filters to serve the same purpose. The difference is that the filtration takes place on the light *before* it reaches the lens. This technique is useful in several applications:

1. When you wish to add tungsten light to existing daylight, but have the artificial (tungsten) light match the daylight color.

2. When you would rather not look at the subject through a color conversion filter on your lens but have the option of filtering the light source instead.

3. When you want to add different colors to various light sources for a special effect.

Tungsten color film exposed to daylight or electronic flash without a conversion filter produces overly blue results, as in the photo at the left. Normal color balance can be restored with an 85B filter, as at the right. However, the incorrect color balance produced a more striking graphic effect with this subject. Photo: B. Sastre.

Repeated flash exposures produce image sequences of movement on a single frame; using a different color filter for each exposure enhances the visual interest of the effect. A different exposure compensation may be required for each filter to get even results. Photo: M. Craig.

When you add filters in front of hot lights, choose filter gels or glass filters that are especially made for such lights. Some common gel materials will melt in front of hot lights. Small electronic flash units (without modeling lights) can be fitted with inexpensive thin gels or colored cellophane.

Chapter 8 has more ideas about creating special effects with colored filters. To obtain filter materials made for photographic/theatrical applications, consult a well stocked photographic or motion picture supply house. You can also write directly to manufacturers for information on their color filter materials and the present cost of sample books showing the various colors available.

Some manufacturers of electronic studio flash units and professional tungsten-halogen (quartz) light instruments also offer specific filters to be used with their respective products. A professional photo dealer or motion picture light supply firm can furnish up to date details and prices for this sort of equipment.

6

Color in Composition

Successful color photographs are created by photographers who master technique so their art can take over. You understand the basics of technique from previous chapters. Now is the time to let your imagination flourish. Color photography has certain general rules or principles, as do the other arts. Once you understand these principles, you can often break the rules with creative results. It is your film, your imagination, so let yourself experiment.

A good way to learn the artistic principles of photography is to consider other art forms such as painting, sculpture, dance and even music. The principles of art involve what certain designs, colors, rhythms and patterns mean to most people. Millions of people who love the arts have never been taught what these rules are, yet they "feel" what an artist wants to express.

Search for the essence in each subject. Knowing what you feel to be the most important trait or aspect of a subject will help you decide on color composition.

For photography, the rules of balance in composition are most useful. Place the main subject facing *into* the frame. Keep the composition tight and avoid extraneous elements. Balance the frame by keeping heavy, broad designs toward the bottom. A composition is usually most pleasing when the main subject is slightly off-center, rather than right in the middle. Gentle curves, running from top to bottom or in an arc or S-shape, are more interesting than straight lines that run directly across or up and down the frame.

You may recall some powerful photographs or paintings that have used these principles to great advantage. At the same time, some great works of art directly challenge the rules, to get our attention. The rules, however, are still valid and contribute toward powerful, pleasing photographs most of the time.

The reflections in the water help add a sense of balance to this composition. The soft light and pastel colors add to the sense of tranquility. Photo: B. Docktor.

Using Color Differences

The principles noted above apply to composition in general and are useful in both black-and-white and color photography. But color photos have an added dimension of contrasting hues. You can use subtle variations in color to separate the main subject from a background, or you can take a bolder approach, creating a background that dramatically contrasts with the subject. In color photography these color differences are important for impact, clarity, emotion and even balance.

The balance within your frame can involve space or color, not just a physical object. For example, by using black seamless paper or cloth, you can create a composition weighted by heavy black space in the frame and place your subject with contrasting color where the eye finds a pleasing balance. When the background is mainly black or white, other colors, even pastels, will look richer by contrast.

A good awareness exercise for you as a photographer is to study professional advertising photographs. Most of the best advertising photography uses contrasting color to effectively put our attention on the important subject. You can apply these same techniques to improve your color photographs by directing attention where you want it.

Contrasts Within Subjects. Color contrasts can occur within a subject and such differences often make dramatic photographs. In nature, such contrasts may occur in flowers, perhaps as a dark lavender lip on a sparkling yellow orchid, or deep, rich black in the center of a vibrant, orange daisy. Some birds have a bright red against iridescent feathers. People may have dark blue eyes that contrast dramatically with light skin.

Sometimes your subject is a combination of individual objects or designs. In a landscape photograph, the main subject is an overall pattern rather than one bush or rock. In such a case, a color contrast may act as an accent or relief from an otherwise dominant hue such as green, brown or blue. Some photographers who specialize in nature/landscape photography carry a red parka or jacket so their models can furnish a color accent. This can be especially useful in photographs with green forests or seascapes in them.

Bright colors are most vivid in direct sunlight. The hard light outlines edges crisply and makes areas of solid color more brilliant. Photo: M. and C. Werner.

Technique Tip: Using Bright Colors

Bright colors, such as red, yellow, magenta, or even silver and gold, call for attention. A bright color tends to draw the eye away from other elements in your composition. Within a composition therefore, it is useful to reserve the brightest colors for your major subject or to make your artistic point. When photographing flowers, for example, you can choose a background color to contrast with the flower color or to complement the flower (as blue does a red bloom). On the other hand, the background might be so bright that it distracts from your flower subject. Avoid a clashing combination which does not complement the subject. A brilliant pink or red background behind a brown or magenta flower will make most viewers uneasy.

Monochromatic Compositions

The fact that color film can capture the full range of hues does not mean your color photographs *must* contain several basic colors. In fact, some of the most dramatic color photographs are monochromatic studies, consisting almost totally of one color. This occurs in photos of foliage, some high key and low key photographs, patterns in bark, sand, etc.

An artistic principle here is that less is more. By subtracting colors, by choosing to include less in the frame, you get more impact from what you do include and automatically make an artistic statement. A good way to use the principle is to create color studies that involve mainly one color — for example, variations on green in leaves or tight compositions of sand or rocks with an overall sepia, gold or gray tonality. Designs in packages or building materials are a rich source of subjects for monochromatic studies. The observant photographer can discover much in bricks, flagstones, gravel or in clusters of boxes, stacks of crates or piles of vegetables.

(Right) You can add spark to a low-contrast monochromatic picture by including a small area of bright color. Using a person as the color accent here adds interest and provides a sense of scale. Photo: M. and C. Werner. (Above) Color accents must contrast well with the overall monochrome hue if they are to add interest and clarify form. Photo: J. DiChello, Jr.

The simplest way to control background and eliminate distracting details is to use a roll of seamless paper as a backdrop. Using seamless paper as a background also eliminates the horizontal line created where the tabletop or floor would meet the wall.

Background Control

In your home or in a studio, control your background by using seamless paper, plainly painted walls (white is best), large cardboard mounting boards or wrinkle-free cloth backdrops, and by careful selection of props or furniture that may appear behind your principal subject. You can make white walls another color by lighting them with colored light. Colored gels (see Chapter 5) over an electronic flash or in front of photo lamps will turn white walls whatever color you want. The same can be done with white cardboard or seamless paper backgrounds.

Using Depth of Field. Although you may not have the freedom to place a paper background behind your subjects outdoors or in a documentary situation, you *can* choose to make the background sharp or blurry by varying the depth of field. Since the widest lens openings offer very shallow depth of field, choose a fairly wide opening (i.e., *f*/2.8 to *f*/5.6) when you want the area behind a subject to be out of focus. In color, this technique is especially useful because an out-of-focus background, such as foliage for flowers or a landscape for informal portraits will often complement your subject.

Depth of field control is also useful in framing a subject with foreground material. For example, an out-of-focus yellow or pink flower can frame a gray or brown structure. Green foliage, well out of focus,

makes a pleasant frame for flower subjects or landscape views. If you want out-of-focus foreground color but there are no natural objects present, consider *holding* something in front of the lens. Often a leaf or small branch, even a single flower, held near the lens will provide a feeling of depth while creating a colorful frame for a more distant subject.

Light and Dark. In addition to color, you can use areas of light and dark to focus attention. The eye will go to light areas more quickly than to dark. If you are composing a picture and wish to direct attention to a specific place, arrange for that area to be slightly brighter than the other parts of the composition. In landscape and documentary photography, a distant light area will also give a feeling of depth.

A dark background will intensify the feeling of brightness in subject areas under strong directional light. The result is a graphic, dramatic emphasis. Photo: B. Barnes.

7

Unusual Situations

You can make very dramatic photographs when you understand how to cope with less than ideal conditions. Elementary photographic instructions may suggest that pictures be taken on bright days with the sun over your shoulder. But by now you are ready to create color photographs with the sun behind your *subject*, in the rain, at night, and even with mixed light sources.

Will your camera capture a rainbow? Yes, if you can see the rainbow your camera will capture it on film. For the most saturated colors take a meter reading off the clouds. Bracket exposures (as explained in Chapter 3) if the view is one that you must have. Take an exposure with the meter set off the sky area, then another one adjusted for any land areas included in your frame.

In addition to photographing rain, storm clouds, rainbows and other natural subjects, search for interesting reflections on wet pavement, windows, car hoods or other shiny surfaces. The period after the rain, just as the sun breaks through, is a fine time for nature photographs. Foliage and flowers look fresh with raindrops and often the sun will reflect directly from drops on a leaf or flower petal. This may be a good time to experiment with a cross-star filter or rayburst effect (see Chapter 8). To get saturated color get your meter reading directly off the reflections, but as always with important subjects, take some bracketed exposures too.

The light on a cloudy day is soft and usually very consistent. Unlesss the clouds are patchy, you can set your basic exposure once and forget about it. However, you may want to bracket exposures to be sure of getting the color saturation and sense of light or dark that conveys the mood you want. Photo: J. DiChello, Jr.

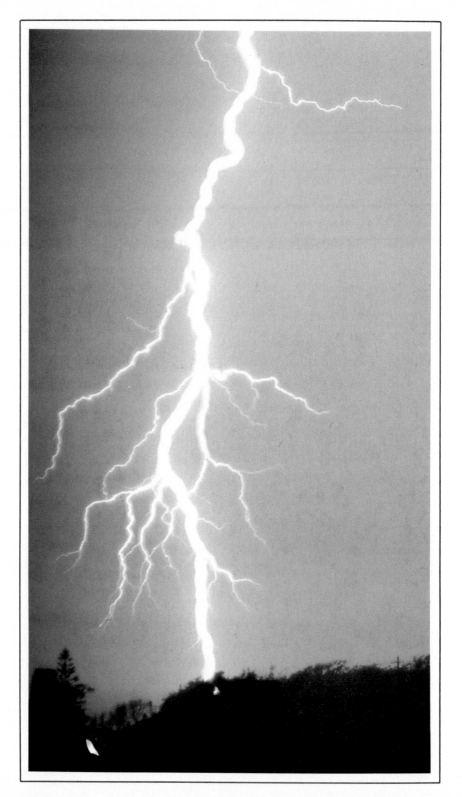

Rainy Weather

Rain is not good for equipment if water gets on the lens or camera, but with a few precautions you can take pictures in or of the rain. A few photographers have underwater cameras, but most people must provide protection for their equipment. Heavy duty plastic bags are ideal for covering a camera and lens. All you have to do is make a hole for the lens. A few companies even offer a heavy duty plastic cover designed just for cameras.

Leave the lens shade on so that the plastic will not touch your lens element or skylight filter. When you are out in the rain, don't rely just on a covering for the camera. Wear a loose waterproof coat or slicker, and keep the camera on a strap around your neck under the waterproof clothing until it is time for the actual photo. Shield the lens from raindrops, unless you want a misty looking photo.

In some situations you can take cover out of the rain, yet still photograph areas that are being drenched—for example in a doorway or inside a building with a window or door open. Photographs taken through window glass lose some sharpness. When you are traveling by car, it is usually possible to pull off the road and take photographs through an open window during a rain storm.

When shooting in rainy weather, carry along a supply of good-quality paper towels to wipe off the outside on equipment that gets wet. Do this quickly so water does not run inside the camera or lens. To clean off a filter or lens element, use only lens tissue; otherwise you will risk getting fine scratches on the glass.

When it is really pouring, the rain will give a blurry look to distant views. If your subject is city lights or if it includes bold areas of color, this effect can be appropriate. If the sky is totally cloudy, your light will be very flat and uninteresting, so using lights or light reflections *as* the subject is a good idea.

In rain (or snow) an on-camera flash will light the nearest precipitation. Keep the flash unit off to the side or use flash as a back light to give an attractive look to rain and snow in the air. Rain hitting water is a good subject for monochromatic color studies, but here again look for instances when there is some light, either from artificial sources or sun breaking through the clouds.

In rainy weather you may have an opportunity to photograph a flash of lightning, but planning is necessary. The camera must be mounted on a tripod and pointed in the direction you anticipate the lightning to appear. Before the lightning flashes you must open the shutter and keep it open so that when the flash occurs it will be recorded on the film.

Snow

Color photographs of subjects against a snowy background are easy to make when you understand how to adjust the camera meter. If an expanse of bright white is "seen" by the metering cells, any subject darker than the snow will be underexposed. The meter, reads the bright white, then recom-

An interesting effect to try with snow scenes is photographing with a blue filter. The blue cast adds a feeling of cold and suggests evening light, especially if you underexpose the film slightly. Photo: O. Gjerde.

Technique Tip: Exposure Test

By taking a few test photographs in which you vary the increase in exposure, you can determine how much of an increase gives the most pleasing results when compensating for snow.

Take one photograph at the recommended *f*-stop. This will most likely give you snow that is too dark and people that are almost silhouettes. Next, if you are using slide film, increase the exposure by half-stop increments, up to 1½ stops. With negative films, make full-stop increments, up to 2 stops extra exposure.

When the pictures come back choose the degree of color saturation you like best. Most photographers will be pleased with the adjustment for a one *f*-stop increase.

mends an average exposure which will make the snow come out gray, actually often gray-blue under open sky, and less brilliant subjects will look too dark. To avoid this effect follow these steps:

1. Adjust your camera for the correct ISO/ASA rating.
2. Compose the photograph and note the meter reading. *If* your composition includes large areas of white, you can get correct exposure by giving one *f*-stop more light or shutter speed one step *slower* than the meter suggests.
3. An alternative method of meter reading under bright snowy conditions (a snowy landscape on a sunny day) is to take a meter reading *close* to the important subject, then use that suggested exposure even though the full photograph may take in a much wider view.
4. If you have an automatic camera that makes it too troublesome or not possible to make these corrections, then trick the camera meter by setting a lower ISO/ASA number. For example if you are photographing people against bright snow with an ISO/ASA 100 film, you can set the meter for ISO/ASA 64 or 50 to assure more exposure.

You can also use the Kodak Gray Card or a handheld meter for an incident-light reading, but these steps are often not practical when you are photographing action in the cold against snow.

Even if your camera has been specially adjusted for cold-weather operation, keep it under your jacket until you need it. Extra batteries kept in an inside pocket will help keep you shooting even on the coldest days. Change the chilled batteries for the warm ones as necessary. Photo: J. Howard/Positive Images.

Keep Warm. Keep your camera under clothing until it is time for a photograph. The camera meter batteries work best at usual temperatures. If the meter batteries get very cold, they are likely to malfunction, which usually produces overexposure. Besides the meter, your camera shutter and moving lens parts should be kept warm for smooth operation.

Photographers who frequently work outside in below-freezing weather have their cameras winterized. A professional camera repair shop can prepare your camera with special cold weather lubricants and cold-resistant batteries so the equipment will still function correctly even when the temperature is below freezing. For most casual winter photography, it is easier just to keep your camera under a jacket to keep it warm between pictures.

Nature Subjects. In addition to photographing people having fun in the snow, look for nature subjects. A sunrise or sunset over a snowy landscape is dramatic because colors are reflected on the snow. Bare branches against snow, close-ups of seed pods, animal tracks, early spring flowers pushing through the snow—all are suitable subjects.

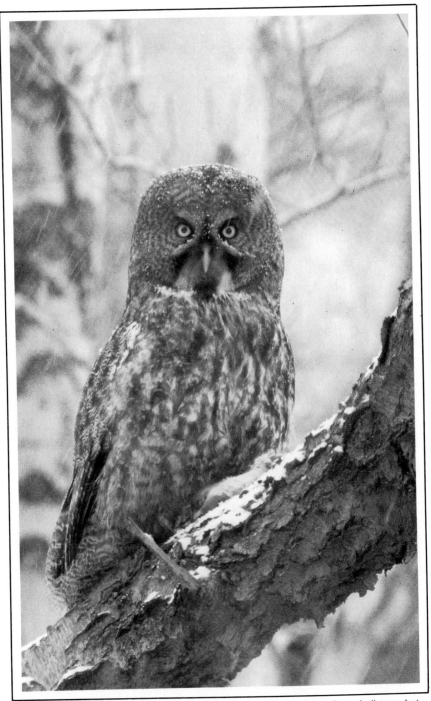

Photographing nature subjects under cold and wet snow conditions is a challenge, but the result can be excellent habitat shots that cannot be duplicated any other way. The light is too low for shooting with long telephoto lenses unless you use a fast (400 speed) film. Contrast is quite flat so you can easily rate the film one stop faster (double the speed) and ask your lab for "push processing." Be sure to follow the precautions you would normally take under rain or cold weather conditions. Photo: M. Fairchild

Technique Tip: Photographing City Skies at Night

For an interesting-looking sky take the photograph just before the horizon darkens. The buildings will often have lights on, yet the sky will still have enough detail to show clouds and some color. To be sure you have *both* an interesting sky and night lights do this:

1. Select a viewpoint for maximum impact. This may be a view from a tall building or a view from a high point above the city.
2. Put your camera on a sturdy tripod and compose the photograph to include dramatic buildings or monuments plus a portion of the sky.
3. Take an exposure just as the sun is setting, while the sky still has beautiful color. Take a meter reading off the sky for saturated colors.
4. Re-set the shutter to take a double exposure. (See your camera instruction manual and Chapter 8).
5. When the sky has become fully black and all the buildings are illuminated, take a second exposure. Start with 1/60 at f/4 on ISO/ASA 400 film or take a meter reading directly off the lights.

Nighttime

Photography at night is quite the reverse of photography against snow. At night your camera meter will see expanses of black, or at least very dark areas, and subjects in this dark sea are likely to be overexposed. For the most dramatic night photographs, you will want full color saturation in the subjects, be they colored lights, people or buildings. To accomplish this, take meter readings from the subjects so your metering cells read a minimum of dark area.

For practical purposes, we can consider photography of spot-lit subjects on a dark background "night" photography, too. An example would be performers on a dark stage where light is directed on the people but not on the background. Such lighting is the rule at rock concerts and some dance performances, especially when one or two performers are being featured.

The first few times you photograph under these conditions keep notes of what exposures you used. Soon you will be able to predict the best shutter speed and *f*-stop combinations for the subjects you enjoy photographing.

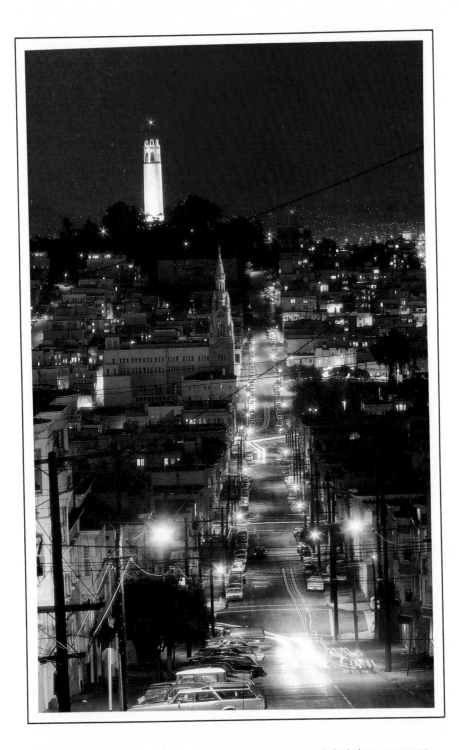

City skylines are exciting to photograph at night. In general, relatively long exposures are required, especially if you wish to retain some detail in the sky. You might want to try the method suggested in the Technique Tip, or experiment with different exposure times. Photo: T. Tracy.

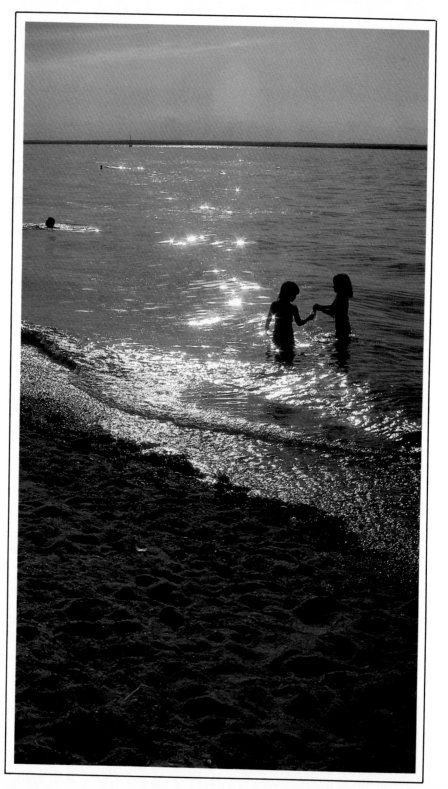

Bright Glare from Sun

Nighttime requires special care for correct exposures, but so does glaring sunlight. Glare or brilliant reflections will cause meter readings to give underexposure, similar to what happens when the meter reads subjects against snow on a bright day. For example, at the beach where the sun reflects off water and white sand, meters react by giving less than ideal exposure indications.

If your subject is positioned against a glaring background and you follow reflected-light meter readings, average subjects will come out very dark, perhaps even as silhouettes. Dark-skinned people especially will look underexposed in these situations. To avoid this, follow the steps for exposure corrections for bright snow.

Cut Reflected Glare. To avoid the silvery glare that reduces color saturation, use a polarizer. You will get maximum glare reduction with the polarizing filter when you aim the camera at an angle equal to that of the sun and your subject. For example, if you are photographing friends on a beach, and the sun lights them at a 45-degree angle, your polarizing screen will work best when you photograph the subjects at an angle 45 degrees from the sun. With a single lens reflex you see the effect directly through your lens. Otherwise you must preview the polarizing effect first, then note the reference mark on the polarizing filter. Watch where this reference mark is pointing, in relation to the light source, when the filter is giving the desired glare reduction. Now screw the filter into your lens and orient it in the same way, using the reference mark to keep the polarizer at the same angle to the light as during the preview. Most polarizing filters come with a folder that explains how the rotating mount works and a diagram giving practical hints for using the device. Remember that the polarizing filter absorbs some light so an exposure increase of 1⅓ to 2 stops will be required. Behind-the-lens meters usually take care of this with no adjustments required.

However, when you are using the polarizer under glaring conditions at the beach, on water or around snow on a sunny day, be sure to make the other exposure adjustments suggested earlier to avoid underexposing average subjects seen in bright surroundings.

Glare can cause false exposure readings, weaken color saturation and contrast, and reduce apparent sharpness. A polarizing filter often will minimize these effects, and a good lens shade also can help a great deal. If the camera is on a tripod, hold your hand or a card just outside the field of view to shield the lens from the glare of a light source or bright reflection. Photo: J. Tomaselli.

A long lens and a hand-held 1/8 sec. exposure recorded this graceful blurring of action and arena. Exposures this long may cause the film's color response to shift expressively, as here. In general, an extra half-stop of exposure is a good precaution at slow shutter speeds. Photo: J. Scheiber.

Long Exposures

Exposures longer than 1/10 of a second are unusual most of the time but may be required for nighttime studies or compositions indoors when the camera is on a tripod and the subject is stationary. For example, to get maximum depth of field you must use the smallest possible *f*-stop, such as *f*/22. With a constant light source, such as the sun or photo lamps, and a slow color film, you might have to make a long exposure.

Some films change their sensitivity to light when exposed for longer than 1/10 second. This effect is called reciprocity, a film's change in sensitivity due to variations in light intensity and exposure time. The reciprocity characteristics of color films are different. If you plan on making long exposures and do not find exposure and filter recommendations in the data sheet supplied with your film, write directly to the film manufacturer for suggestions.

Reciprocity failure is a common occurrence with long exposures. The change in the film's response to light causes uncontrollable color shifts. Often the shift is toward green, as in the left side of this photo.

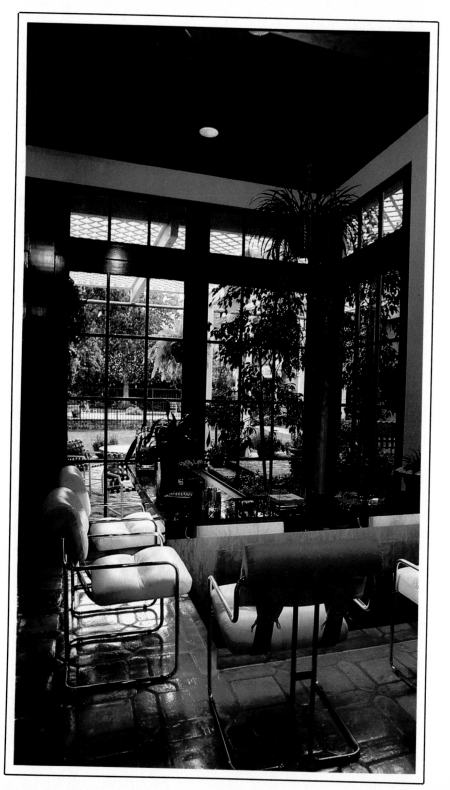

Mixed Light Sources

Color film exposed under lights with different color temperatures will give unusual results. If you mix light sources, the color photographs can be exciting as experimental pictures, but avoid mixing light sources of varying temperatures if you expect the most normal-looking color. True colors result from a correct matching of film balance with light color.

Indoors/Outdoors. A common situation where mixed light sources might be useful is in a photograph taken indoors, but with some light coming from outside. Often a window or patio may be seen in the same picture as indoor subjects. To get a correct exposure for the outside portion requires a much shorter exposure than for the much dimmer area. To get the correct exposure for both bright and dark areas, you can add light to the indoor subject.

To get an accurate color rendition, use daylight film, then add indoor light which has a daylight color temperature. You can balance artificial light for daylight film by:

1. Using an electronic flash which is balanced for daylight film.

2. Using tungsten-halogen (quartz) lamps fitted with glass daylight (dichroic) filters.

3. Using blue flash bulbs.

4. Using blue photoflood lamps (for a slightly warmer than "true" daylight look; dichroic filters on quartz lamp instruments are closer to daylight film balance.)

5. Using blue gels in front of tungsten-halogen (quartz) lamps. Photographic gel material, made to be held well in front of hot lamps, is offered in blue shades to give precise Kelvin changes, thus turning 3200 or 3400 lamp light into daylight color.

This is an example of a mixed light situation where an incorrect color balance is used to beautiful effect. The daylight-type film gave an accurate rendition of the outdoor scene through the window, but it yielded a very appropriate warm yellow-orange cast with the incandescent interior lighting. Photo: T. Tracy.

Many people prefer slightly warmer than normal (more orange/red) colors to cooler than normal colors (blue tints). This means that you will probably like results from *daylight*-balanced film when some of the light is warmer but not the reverse. For example, if you were to use a tungsten-balanced film (such as Ektachrome 160) in light that includes both daylight and tungsten lamps, the results would be cooler, more blue, than desirable. Remember that color negative (print) film is corrected for average skin colors when prints are made. Therefore if you mix daylight and tungsten lights, the prints may look acceptable, at least when there are people in the pictures.

When daylight film is exposed under tungsten light the result will have a yellow-orange cast. Sometimes, the results can be pleasing but control is lacking.

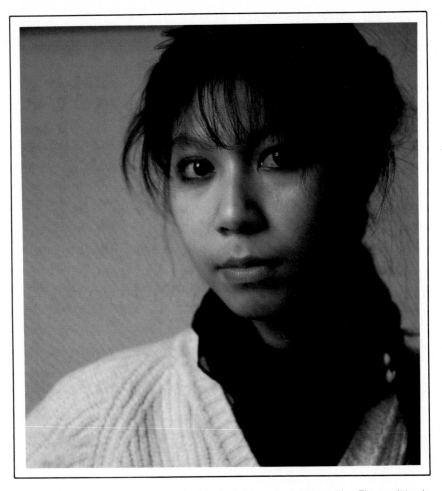

Here the same subject is photographed in daylight on daylight type film. The rendition is cooler, but this is what most photographers would refer to as "proper color balance."

Odd Reflections. Some strange color tints result in situations where a subject is close to a broad area reflecting colored light. If you use an electronic flash aimed at a wall or ceiling for softer bounce light effects, be sure that the bounce surface is white. Light bounced from a blue wall or ceiling will come back to the subject as blue-tinted light. There may be times when you want to use a colored reflection to change a subjects's usual color. For example, reflecting light from a gold foil sheet may make human skin look healthy and tanned.

Outdoors under open blue skies, color film will register more blue than our eyes see, thus producing pictures that look too cool. Keeping a skylight filter on all of your lenses will do much to eliminate this problem. If the results under clear blue skies are too cool even with a skylight filter, consider using a slightly stronger warming filter (81A or 81B).

8

Creating Color Effects

You have learned how to get accurate color by matching film balance to light sources, using corrective filters, providing precise exposure—all to deliver pictures with "normal" color. But sometimes you may want to create special effects that differ from what is usually seen. Creating your own color effects is an exciting part of color photography and very easy to do.

With a few accessory filters you can drastically change the color of a subject. Filters for unusual effects come in several mateials. The least expensive are thin gelatin filters. Of those, gels with high optical quality are the most expensive, but give the sharpest results. For the highest degree of sharpness, use gelatin filters which can be held in a frame in front of the lens. Where slightly less sharpness is acceptable, experiment with the many colored gels offered by manufacturers of theatrical gels. The advantages of gel filters are light weight and relatively low cost. The disadvantages are that gels are easily damaged and are not as easy to use as screw-on glass filters.

Hard plastic filters and unusual prisms are offered by several firms. The advantages of these scratch-resistant, rigid, usually square filters are moderate price and relatively large size. Since the filters are larger than the front lens elements of most cameras, you can buy various-sized adapters (49mm, 52mm, 55mm etc.), then use a universal filter holder on all of your lenses. If your lenses all have the same lens accessory size, this universal adapter feature is not needed.

Solid glass filters made for photographic use offer the advantages of maximum optical quality, compact size and durability. The best glass filters are coated with anti-reflection material, as are good-quality lenses. With good lens tissue and lens cleaning fluid, you can clean glass filters with minimum danger of scratching.

You can easily depart from "normal" color by keeping a small array of filters at hand. A red filter was used here to accentuate the feeling of radiant heat from the sun. Photo: R. Mullins.

Color Filters

To create an overall color tint in your photograph, use a solid color filter. These are offered under various names for special effects, but you can also use the standard colored filters used in black-and-white photography. These are widely available in yellow, green, orange and red. Color conversion filters can also be used in unconventional ways to get an unusual effect. For example, a blue 80A filter used with daylight film outdoors or with electronic flash will give a blue-toned picture. This can be used to advantage when you wish to create a nighttime effect; just use daylight film, a deep blue filter, and underexpose by ½ to 1 stop.

Partial color tints are easy to make also. To do so, hold a colored gel or filter over part of the lens, tape colored gel material to a skylight filter (keep tape at the very edge) or use a special filter that is tinted in one section, clear in another.

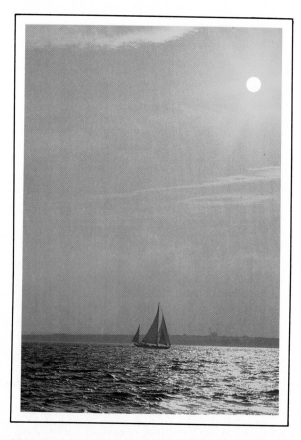

Commercial filters come in a wide variety of colors and color combinations. Square filters can be adapted to lenses of many different sizes with a universal filter holder; screw-in type round filters must match the front ring diameter of a particular lens. Here an orange filter is used with daylight-type film. Photo: B. Sastre

To get partial color tints, place a filter over just part of the lens. There are also special filters that are partly colored and partly clear. Use the depth of field preview control on your camera to check the precise effect at the lens aperture you will use. Photo: B. Sastre.

Remember to check depth of field with the camera preview button, especially when filter materials are held in front of the lens. As the *f*-stops become smaller, precise junctions between clear and filtered areas become more visible. These partially tinted filters are called graduated if there is a smooth transition between areas. Other types are called half-filters because there is an abrupt change from the filter to clear area.

You can alter the effect of these half filters by combining them with a polarizing filter. For example some filters change color from a mild tint to deep color. One design offers a bi-color effect, such as red and blue or green and purple in the same filter. By rotating the filter mount, you can color-tint the desired part of your picture. Turning the polarizer varies the color saturation from slight to deep. This screw-in filter design is easy to use and can be ordered to fit your lens-accessory size.

The plastic filters designed to be held in the special adapter can also be used to get blended colors. To get two different colors in the same picture put two different-colored plastic filters in the holder, so that each filter covers a different part of the lens. For example, you could tint the sky a deep orange while making the ground blue or green. Behind-the-lens metering systems will usually give good results with such tinting methods.

For the graduated filters, where only part of the frame is affected by the filter, you may have to give slightly *less* (½ to 1 stop) exposure than the meter suggests to get the full color effect. Filter manufacturers provide exposure recommendations with their products.

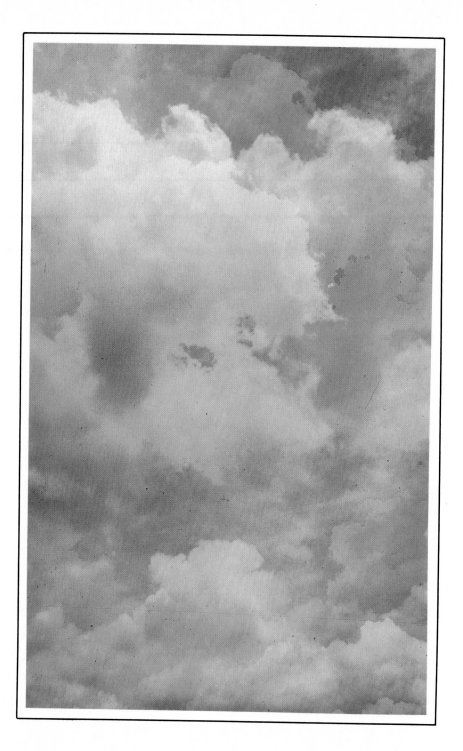

For multi-colored effects, try exposing the same scene separately through three different colored filters. Remember to divide your exposure time by the number of exposures you will be making. Photo: G. Dunn/Atoz Images.

Technique Tip: Multiple Exposures
with Several Filters

To get a multi-colored effect on waves, passing clouds or a waterfall, do the following:

1. Mount the camera on a sturdy tripod.
2. Compose the picture and take a meter reading.
3. Set the lens one stop *more* exposure. For example if the exposure suggested is 1/60 at *f*/11, use *f*/8.
4. Screw in a red filter or hold it in place and make an exposure.
5. Re-cock the shutter and make a second exposure through a second deeply-colored filter, perhaps a green.
6. Re-cock the shutter again and make the third exposure, perhaps through a dark blue filter.
7. Advance the film. If your camera does not always make precise multiple exposures, advance the film twice (take one shot with the lens cap on to get a blank frame) to prevent an accidental overlap.

This effect looks best when most of the stationary part of the subject matter is dark, such as deep brown rocks along the sea coast or dark woodland around a sparkling stream. Remember that color negative film has more latitude for over- or underexposure. With these unusual techniques, you are more likely to get acceptable results the first time with print film than with slide films.

Multi-Colored Filters. Some filters are made with three different colors in the glass. Use these for quick easy multi-colored effects. Take the photograph with a rather wide lens opening such as *f*/4 to *f*/2.8 for a gentle blending of the color edges. You can actually make your own multi-colored filter by coloring a skylight filter with felt-tipped, colored-ink marking pens, or by taping sections of thin colored gels over the skylight filter or onto a lens hood. Naturally all of these colored effects can be combined with other creative techniques.

Other Filters

Diffusion Filters. Some subjects look best when they appear slightly misty. A romantic mood is created when one sees a bride and groom in a picture with misty edges or a softly diffused look. The least expensive way to get this effect is to breathe on a skylight filter just before you take the exposure. A more permanent method is to put lip gloss or petroleum jelly on a skylight filter, leaving just a center circle clean. With this method, the widest apertures will give trhe most diffused effect.

Less messy to handle are glass filters made to diffuse or soften the image. Some are made by grinding the glass to make many small scratches, others have a rippled pattern, and still others look almost clear, yet produce a beautifully uniform softness over the whole image. These filters do not absorb enough light to require additional exposure. These soft or diffusion filters are effective for flower photography and for softening skin wrinkles in portraits.

Diffraction Filters. Filters that make a multi-colored pattern of light from any direct light source are called diffraction filters. Some manufacturers offer more than one type, and the names of these special effects

Diffusion filters add a misty, romantic effect to your pictures. You can make your own diffusion filters by smearing standard skylight filters with varying amounts of lip gloss or petroleum jelly, or you can buy them ready-made. You can vary the effect by the aperture you select; the wider the aperture, the softer the result. Photo: D. Cox.

Use a diffraction filter to get multi-colored effects from direct light sources in the picture. These filters are available in a number of different diffraction patterns. Photo: F. Davis.

filters are not standard, so look through the filter you are considering before purchasing it, or request color illustrations of the effects of each type.

Diffraction filters are fun to use for creating highlights of color in otherwise somber pictures. In a nature study consisting of a dark lake, deep green foliage and a blue sky you can introduce a burst of red, blue or yellow radiating from the sun with a diffraction filter. Bright light sources or light reflections will produce maximum bursts of color. Without a small, bright light source in the picture, the diffraction filters make less dramatic results, usually just a slight softening of the image.

You can combine a diffraction filter with a diffusion filter to create a dream-like or psychedelic effect.

For a special color effect like this, try combining a star filter with a diffraction grating. Photo: J. Scheiber.

Star Effects. To turn a direct light source into a star-like pattern, use a star filter. Simple star filters are single pieces of glass cut with fine lines to make stars of various types such as 2-point, 4-point, 8-point. More complicated star filters have two sections of etched glass that can be rotated independently to make the star rays go where you wish.

When reflections from a subject are slight or very small, you will see only a slight effect from the star filter, but as the light reflected becomes larger so will the star effect. Star filters are generally of clear glass and so require no exposure compensation. Nice color impressions can be created by using a star filter with a diffraction filter.

Subjects with many light sources in the picture area are ideal for photographing with star filters. Night scenes offer many opportunities to utilize this special effect. Photo T. Tracy.

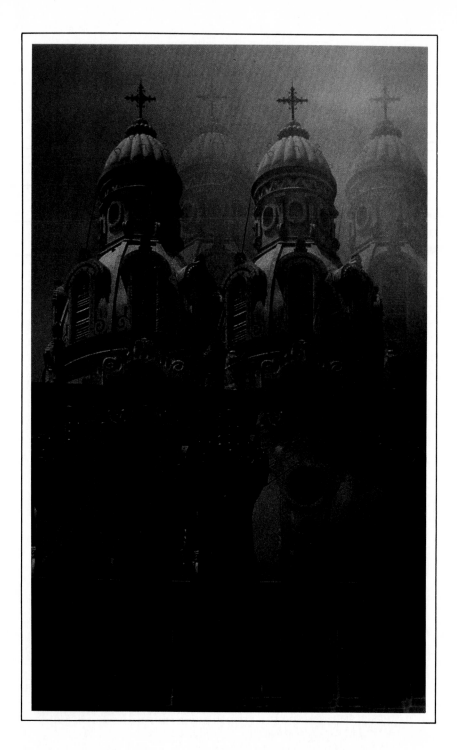

Multiple exposures with significant overlapping or against a light background require decreased individual exposure. Divide the meter indication by the total number of exposures. For a double exposure, each exposure receives one-half the normal amount of light—that's one stop less for each exposure. Photo: D. Cox.

Multiple Images

Multiple Exposures. When the whole frame is exposed more than once, special exposure calculations are usually required since you have given the film twice the standard exposure. Therefore when planning a double exposure, give each photo one stop less exposure than normal. The accumulated exposure will be correct.

As with most of these special effects, the exposure manipulations suggested are averages. You must adjust exposure according to your experience and personal preference. The subject for each of the multiple exposures will also influence what the final picture will look like. If you are exposing one part with a light subject such as a sky with white clouds, you might prefer to underexpose the first exposure by 2 stops.

When you put subjects against a black background, it may be possible to make two or three exposures without any special exposure adjustment. If you keep light off the black, it will give so little exposure that your background will not show up. This means that you can take the first exposure at the setting suggested by the meter or calculated for your flash. Only the subject with average reflectance will register when you expose correctly. The black will stay black. For the second exposure, you can line up a subject with another black portion of the frame and expose the second time normally.

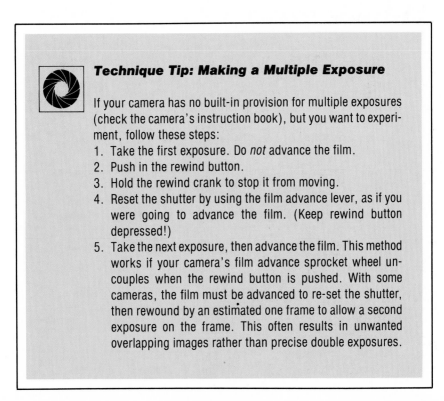

Technique Tip: Making a Multiple Exposure

If your camera has no built-in provision for multiple exposures (check the camera's instruction book), but you want to experiment, follow these steps:

1. Take the first exposure. Do *not* advance the film.
2. Push in the rewind button.
3. Hold the rewind crank to stop it from moving.
4. Reset the shutter by using the film advance lever, as if you were going to advance the film. (Keep rewind button depressed!)
5. Take the next exposure, then advance the film. This method works if your camera's film advance sprocket wheel uncouples when the rewind button is pushed. With some cameras, the film must be advanced to re-set the shutter, then rewound by an estimated one frame to allow a second exposure on the frame. This often results in unwanted overlapping images rather than precise double exposures.

Prisms. A way to get multi-image effects *without* multiple exposures is to use clear glass prisms. These are designed to screw onto your lens, are easy to use and require no exposure increase. As with other special-effects filters, these prisms come in many different designs. You will understand what each does by looking at photographs produced with each prism, or by looking through the prisms themselves. These are not inexpensive; each well made prism will cost about the same as three or four good standard filters.

One useful design has a clear center surrounded with four angled prism facets. This prism gives you a sharp rendition in the center of the frame, then produces softer multiple images around the central image. Such an effect is an ideal way to fill the whole frame with color. Check prism effects with a single lens reflex camera by using the depth of field preview button. Small apertures make the facet edges more distinct. Wide open lenses blend the edges and create a softer transition between the facets, which often looks nicer in color.

You can combine several prisms for different effects, but if the total thickness extends too far in front of your lens, the image corners may be darkened.

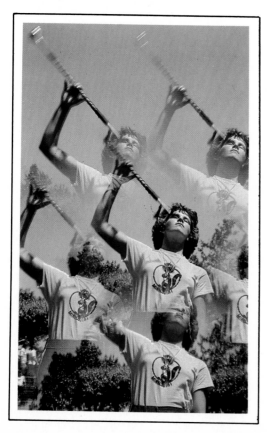

Clear glass prism attachments are an easy way to get multi-image effects. Use wide lens apertures to minimize sharp delineation of the facet edges. Photo: A. Moldvay/Editorial Photo Services.

Repeated flash exposures will produce multiple image effects if you can work in a very dark location. With the camera on a tripod, open the shutter of the B setting and fire the flash unit with the "open flash" or "test" button each time the subject changes position.

Multiple Flash Exposures. An interesting multiple-exposure effect can be produced in the dark, either outside at night or in a dark room, by exposing with several bursts of electronic flash or flash bulbs on a single frame of film. To get this effect proceed as follows:

1. Set the camera on a tripod.
2. Set the shutter to the "B" setting.
3. Determine the correct exposure for the flash-to-subject distance for the film you are using.
4. Set the lens at the correct opening.
5. Turn out any lights that might illuminate the subject.
6. Take the first exposure. The shutter will open and the flash will go off—*hold down the shutter release to keep the shutter open.*
7. As the subject moves, fire off the flash unit for several more exposures with the open flash button.
8. Let go of the shutter release to permit the shutter to close.

Variations on this can be done with cameras that have a "T" shutter setting. This setting keeps the shutter fully open without the shutter release having to be held down. The shutter is finally closed when the film is advanced. For exciting color effects put a different colored gel over the flash for each of the various flashes. Note that electronic flash units recycle faster on their lowest power settings.

Sandwiching slides offers numerous creative effects. Light (overexposed) slides work best, but you'll have to determine which images go together well. Be careful in removing slides from their mounts and in combining them, they can easily be scratched. If you shoot slides with sandwiching in mind, specify "unmounted" to the lab so you can minimize handling. Photo: J. Scheiber.

Sandwich Effects

Put two original slides together in the same slide mount for a sandwich effect. This technique is fun and can rescue some of your overexposed slides. If you have two views of a friend but both are slightly too light, experiment by holding the slides together in different ways. If you find a combination that looks interesting, do the following:

1. Cut the slides from their cardboard mounts, using a sharp artist's or matte knife.
2. Using care to hold the slides by the very edge (to avoid finger prints) put the two transparencies together.
3. Insert the sandwiched slides into a new plastic slide mount.

If you find it difficult to do this without touching the slide image, wear a white cotton glove or hold the slides with a clean sheet of lens tissue. Slides that are slightly light or pastel-looking are best for sandwiches. Dark slides may be too dense for easy projection. However, you can make effective combinations of a dark section in one slide with a light area in the second. Some photographers enjoy these sandwich effects so much that they take their original photographs specifically for sandwiching later. Seamless paper is very useful in such a case, because it gives you total control over the background color.

Vignetting

If you want to darken the corners of the picture, put a cut-out black frame in front of your lens. You can make such a vignetting device with cardboard, or you can use a lens shade that is too long for the lens. More precise vignettes are produced by screw-in holders or masks that fit in front of the lens. The most versatile are those with an adjustable bellows, sometimes called matte boxes. These attach to the lens but the bellows can be extended so the cut-outs or masks can be placed at various distances from the camera lens.

Some manufacturers that offer plastic filter systems also sell holders to use for masks and vignetters. You can get precise outlines by inserting cut-out masks—in the shape of a star, a key hole, a heart, etc.

To get a masked double exposure do this:

1. Insert mask with the cut-out image and take the first exposure.
2. Re-cock the shutter for a double exposure.
3. Remove mask with cut-out.
4. Insert new mask that is clear except for a black area corresponding to the previously exposed area.
5. Take the second exposure.
6. Advance film.

You have made 2 different exposures on one frame of film but since each portion has only been exposed once you will need no special exposure calculations. Expose as the meter suggests for each of the views.

Masking gives you a shaped frame that can add meaning to your picture. Masks are usually held in front of the lens in an extended filter-mounting adapter or a bellows-like device called a matte box.

Copy Techniques

You may want to copy some of your favorite photographs. Reasons for doing copy work yourself include creating a negative from a print when the original negative may not be available; creating special effects by copying a print or slide through filters, prisms, colored gels, etc.; copying so that you can crop an image; copying instant prints to get a negative or slide; copying black and white prints to make a slide.

Print Copies. To copy a print, use a macro lens or screw-in close-up attachments with an f-stop of f/11 to f/22. (Larger f-stops with screw-in close-up lenses produce decreased sharpness.)

1. For precise alignment, set the camera on a tripod.
2. Hold the print very flat with rubber bands at the edges, out of the frame, or use double-sided tape to fasten the print to a mounting card. Mounted prints will stand straight and stay flat.
3. Use even lighting, with care to avoid glare or reflection, especially from glossy prints.
4. Compose and focus. For slides, compose to show only what you want. If you are using negative film, your composition can be slightly looser since cropping is done at one or both sides when commercial labs make machine prints.
5. Take a meter reading from a gray test card held directly on top of the print to be copied.
6. Take one exposure at the recommended setting.
7. Take a series of bracketed exposures. For slide film, bracket a half stop lighter and a half stop darker. For negative film, bracket by one full stop each way.

Slide Copying. You can copy slides in several ways. The least troublesome method, and one which gives excellent results, is to use a screw-on slide copy attachment designed for single-lens reflex cameras. These devices are offered with simple slide holders and a diffusion plate to make lighting even. If you have a macro lens that will focus to a 1:1 (same size) image alignment, then the least expensive slide copying device will work.

If your lens will not focus that closely, choose a slide copy device that has built-in close-up lenses so that a normal (50-55mm on a 35mm SLR) lens will give a 1:1 copy of a 35mm slide. Still more sophisticated and versatile copy devices are those made to fit onto a bellows. If you already have a bellows unit, consider getting a slide copy attachment made for it. The bellows units may offer closer than 1:1 focusing so that you can enlarge portions of the slide.

To copy slides with these devices proceed as follows:

1. Load your camera with an appropriate film for the light source you will use.
2. Set the camera on a tripod set up so that the light source is in front of the lens. You can use daylight reflected off a pure white card, but

Copying your photographs is not difficult. Use a tripod-mounted camera with a macro lens or screw-in close-up attachment. The print you are copying should be perfectly flat and lighting should be completely even.

avoid open blue sky unless you want slightly blue results.

3. Insert the slide and focus carefully.
4. With a constant light source such as daylight or tungsten lamps, you can take a meter reading through the camera lens. For electronic flash you will need to make tests unless your camera has some automatic feature that adjusts for flash exposures in a copy situation.
5. Make the recommended exposure plus bracketed exposures as described in the Print Copying section.

Best results are attained with films that have slow film speeds. You can also make fine-grain black/white copies. Again, use low-speed films.

Off a Screen. You can also copy projected slides directly off a screen. If the screen has a pattern or is not completely smooth, project the slides on clean white matteboard. Keep the room dark. Take a meter reading directly off the projected slide. Use a tripod for precise cropping and for the long exposures required. Tungsten-balanced slide film will give good color for projected slides.

Infrared Film Effects

If you really enjoy seeing everyday subjects with strange colors, experiment with Ektachrome Infrared Film. This film is used mainly in aerial photography and various scientific applications, but you can obtain it in 35mm magazines from many Kodak dealers. For best results the film must be kept cold until you are ready to load it into the camera. Store Ektachrome Infrared film in the refrigerator or freezer at −23 to −18C (−10 to 0F). Let the film reach room temperature before opening the film package and loading the film in dim light.

For very unusual color renditions of common subjects, try Ektachrome Infrared film. This film has basic daylight speed of 100 and needs a No. 12 yellow filter. Bracket exposures and make notes with your first trial roll. Keep unexposed film cold and have exposed film processed as soon as possible. Photo: H. Weber.

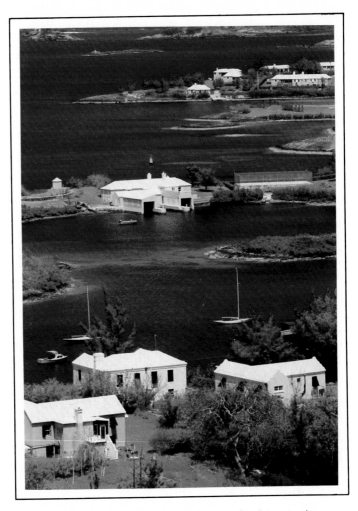

Infrared color effects take time to master. The film has a tendency towards high contrast—something to keep in mind when looking for subjects to use it with the best advantage. Photo: H. Weber.

Kodak packs instructions with this film, and you can obtain very detailed information about infrared film applications in some of the Kodak technical publications. For general use, begin by rating the film at ISO/ASA 100 in daylight, with meter readings taken with a hand held meter or through a lens that *does not* have a colored filter. Before exposing the film, put a dark yellow No. 12 filter on the lens. You can also use a lighter-toned No. 8 yellow filter for fun photos, but the No. 12 deep yellow filter is recommended to absorb blue light. When shooting your first roll of this unusual film, keep notes regarding the exposures given and filters used. For subsequent rolls, you will learn how to get the effects and colors most desired. Have the film processed as soon as possible after exposing.

9

Presenting Color

Presenting your color photographs is a rewarding part of photography. When you show your best work, you bring pleasure to others and receive welcome compliments. If you have created color photographs to teach or inform, it is now that your efforts will have an effect. When you show your work in the form you choose, the artistic process is complete. You began with an idea or observation and worked with artistic and technical understanding to capture your vision on film. You are now ready to present your achievements to others.

For permanent display, prints are a logical choice. Color negatives and slides both yield excellent full color prints when processed by a top-quality lab. Look through your work carefully to pick the very best views. Some photographs look fine in small-sized prints but begin to show blur from subject or camera movement if they are greatly enlarged. Examine slides by projecting them in a projector with a sharp lens or by looking at them through a strong magnifying glass. Some photo dealers have a photo lupe glass on hand and will be happy to help you determine the quality of a slide or negative.

An important factor in displaying your color photographs is determining the maximum image size that retains an impression of sharpness. Projecting a slide or viewing it with a magnifier will reveal any blurring from camera or subject movement or focus error. Photo: H. Weber.

Color Prints

After you select the negatives or slides you want enlarged for prints, follow these steps:

1. Choose the best possible photographic lab. For standard machine prints and routine cropping, the Eastman Kodak Labs and a few of the national photographic chains do a suitable job, with appropriate re-printing if the first prints are not correct.
2. Use a custom lab if you want specific cropping, if you need manipulation such as color correction or making some areas lighter or darker, and if you want special surface papers.
3. Choose the paper surface you want. Even machine-made prints are offered in glossy and a silky type surface. Other surface types are available from custom labs. Some papers give a canvas look, tweed pattern, wood grain pattern, etc.
4. If you want all of the negative or slide to show up in the print be sure to specify FULL FRAME PRINT. Not all labs offer this service, and some offer full-frame prints only in certain sizes.
5. Show the cropping you desire with pencil lines on cardboard or plastic slide mounts. For color negatives, have a small print made, then draw cropping marks directly on the print. Write a note for any directions that may not be obvious from your markings.
6. Write a note requesting any color changes you might want or other color preferences. For example, "print for full color saturation" or "make lighter than slide"
7. Decide if you want the lab to treat your prints with a spray (glossy or matte).
8. Tell the lab if you want prints with or without borders.
9. If you want the prints mounted and/or framed, give these instructions when the prints are requested. Many custom labs offer mounting and framing at bargain prices.
10. Carefully mark slide mounts with your name and address.

Should you decide to use a mail order lab, be sure to protect your slides or negatives between two sections of stiff cardboard when mailing them out. Mark the envelope "PHOTOS—Please Don't Bend." Send these originals first class. Insure them if they are truly irreplaceable.

Negative Care. A word about handling negatives. Always keep negatives well protected in envelopes made for them. Plastic negative files or glassine envelopes are best. Let the negatives stay in strips since smaller individual negatives are almost impossible to put in negative carriers or otherwise position in the enlarger. You can indicate which frames are to be printed by listing the frame number printed at the edge of the negative. Handle negatives as little as possible, and then only by the very edges or with white gloves. Fingerprints and scratches show up quite well in enlargements.

Spotting

If there are dust spots on the color prints your photographic lab should spot them out. Normal spotting for prints made from good-quality negatives is included in the print price. If your negatives are badly scratched or very dirty the lab may charge extra for getting rid of the dust and scratch marks on the final prints.

You can learn to do your own spotting, but on color prints this requires special color print spotting colors. You can get these at a photographic supply store. Before spotting an important print, practice on an old or unwanted color print. Be sure to use an almost dry brush with a very fine tip. A No. 0 brush is very good. Keep the brush tip fine by rolling it around on smooth paper or a plastic filter case.

Begin spotting a dust speck with an almost dry brush tip, using a color slightly lighter than the surrounding area. Hit the paper with a tap or spot action, not a stroke or long painting action. Gradually, after a few hits of the brush tip, the spot will become the same color as adjacent areas of the print, then disappear. This is a corrective technique to get rid of small dust spots. More extensive correction, called retouching, requires great skill and practice. Some custom labs offer retouching services, usually charged for by the hour.

The three most common retouching brushes are shown here.

A collage based on a theme or story can be a kind of picture essagy in a single frame. With a collection of prints, vary the sizes and arrange them to suit. Once you have the effect you want, use double-sided tape to fasten the arrangement in place. Copy the collage before framing it. Photo: C. M. Fitch.

Collage Ideas

An excellent project involving multiple images is to make a collage. Often you can base a collage on a specific theme such as a vacation, birthday party, religious event or favorite flowers. If you make crafts or collect something, consider making a photograph collage showing aspects of your hobby.

The collage begins with a selection of color prints, but your collage prints need not all be the same size. In fact a collage often looks best if the prints vary in size and you tear or cut them to fit. Before making the arrangement permanent, move the prints around, searching for a pleasing or meaningful pattern. When you have finished experimenting, put double-sided tape or transfer tape on the back of each image.

Step by step, so that you will not forget what goes where, put the collage together permanently. When the design is finished and all the prints are fastened down consider taking a photograph of your creation (See copying techniques in Chapter 8), both for protection and also to have enlargements made. A personally created collage is the type of "photo" that makes a good greeting card or a big mural-type enlargement. After you photograph the collage, protect it in a frame behind glass, plastic, or with a protective color print spray.

Slide Presentation

Projecting your color slides is the best way to show them. For quick previews you can use a small hand held or desk-top slide viewer, but these only enlarge the slide slightly. The small portable previewers can be seen by three people at once, but for larger groups projection is much better. Select a projector that has a built-in fan to prevent heat from fading or warping your originals. One of the best slide projector designs uses a gravity drop system, which seldom if ever jams or damages slides.

Prior to projecting your slides look at each frame and take out those that are not good enough. However, remember that some overexposed color slides may make interesting sandwich effects (see Chapter 8). Once you have gone through the slides, put the good ones into a slide tray. The correct way to do this varies according to the projector you are using. For the popular slide projectors which use the circular slide trays, do the following:

1. Look at the slide from the front of the picture itself. For slides processed by Kodak, this will be the blank side of the cardboard mount.
2. Hold the slide correctly, with the top up, then turn the slide upside down.
3. With the slide upside down but the white side still facing you, drop the slide into the slide tray slot No. 1.
4. Continue dropping slides into the slide tray, always with the white side facing you and the image upside down.
5. After all the slides are inserted into the numbered tray slots, put on the retaining ring to keep the slides in place.
6. Put the tray on your projector, turn out the room lights, and enjoy the show.

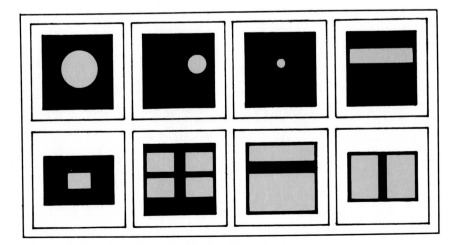

Masks for slides can bring variety to any slide presentation. Masks are available commercially or they can be made by cutting fully exposed and developed film to size and mounting it with the slide to be masked.

If you are going to present a number of slides, edit your views carefully. Home slide shows have a bad reputation only because many photographers have not learned to edit their work. One should not show mistakes (except perhaps to a photo club where mistakes have an educational value). Avoid showing many similar shots of the same subject. Select the best pictures, then arrange them in an order that pleases you.

For travel photographs, a logical way is to arrange slides according to location. Within each situation use the motion picture technique of showing a wide view first, then a medium view, finally a close-up. This orients your viewers and will make your show move smoothly. Project the slides in a very dark room for best color reproduction. Use a clean screen held flat or a big section of white matte board.

If you have a favorite slide program that will be shown often, consider having a taped audio track. If you want to deliver your narration live each time, just tape sound effects and music on a cassette tape, then start and stop the audio tape when you want (fading the volume in and out for a smooth, professional sound).

Should you want to record your comments in precise synchronization with specific slides you can do the following:

1. Make sure the audio cassette covers the time allotted for the whole program. Prepare a written script, double spaced, with a notation, perhaps a bold red dot, to signal where each slide is to be changed. For an extra guarantee that the audio will match the visual, note on the script what slide should be showing with each section of the narration. For example at the far left of your script page, you would put the image, such as AIR VIEW RICE FIELDS, and at the right side your narration: "In Thailand the main food crop is rice, with thousands of flooded acres being cultivated, as seen here near Chiangmai."

2. If possible, tape your audio portion on a special cassette machine designed to automatically advance a slide projector according to a pulse you add. This requires that a connection be made between projector and the audio recorder. The pulse signal is usually inaudible. This system will permit your program to be played back in perfect synchronization. However to do this you must not only have the correct tape recorder, but also a slide projector that will accept the automatic advance pulse signal.

3. A simpler approach is to tape your audio track as you wish but include an audible signal to indicate when each slide should be changed. This is a simple approach and will pemit your cassette or reel to reel audio track to be used on any recorder in connection with any slide projector. However the audible signal can be distracting since it will occur before each slide change.

To hold audience interest, edit tightly to get a slide show that presents only your best pictures in an interesting order. Photos: M. Fairchild.

To mat a print, first mount it on stiff mounting board. The mat is a second piece of board with a window cut in it, over the face of the print. Use a stiff backing board behind this sandwich. A glass cover over the front will give protection from dust and dirt, but not the fading effects of direct sunlight.

Protecting Slides

Color slides last longest when stored away from light, in a place with moderate humidity and moderate to low temperatures. Ideal conditions are a relative humidity of between 15 and 30 per cent. High humidity encourages fungus to grow on the gelatin and very low humidity may cause slide film to become brittle. Store slides in the original boxes used by photographic labs to return your processed slides or in cabinets made for slide protection. Plastic pages designed to hold color slides are suitable for short-term use, such as mailing slides, but these plastic pages should not be used for long term (years) protection since slides may stick to the plastic. Some plastics may, under certain conditions, give off chemicals that can harm colors.

In most homes, you can safely store color slides and prints in general living areas. Avoid hot attics and damp basements. If humidity is very high where you live, consider keeping slides in a sealed cabinet with silica gel packets placed inside, or in a room where air conditioning keeps humidity at a moderate level.

Constantly projecting color slides will gradually cause colors to fade. If you have some valuable original slides that would be impossible to replace, consider having duplicates made. Project the duplicates rather than the originals. When you do project original slides, be sure the projector is a well-designed type with a fan and heat-absorbing glass. Project the slide for a short time only. Leaving a slide projected longer than 60 seconds will increase the chance of damage from heat.

Technique Tip: Simple Mounting

If you prefer to mount your own prints, do the following:

1. Select a print mounting system available at photo stores. These provide for mounting prints with special adhesives that do not harm color prints, most incorporating the adhesive with a mounting board.
2. As an alternative, select a mounting board at an art store and mount the print with double-sided tape or transfer tape.
3. Decide if you want to put the print behind glass or not. Prints not protected by glass can be protected with a thin coating of plastic photo print spray, available at art and photo stores in glossy or matte finish. Follow directions on the spray container.
4. Choose a method for hanging the print. Some excellent teakwood frames offer an easy-to-open sliding top section which permits you to slide in the mounting board on which you have mounted the print. No glass is required. The frames hang quickly from a small hook nailed to the wall. Easy to open frames have the advantage that you can quickly change prints for a new look every once in a while.

Mounting

If your color prints will be placed in albums, you may not need to mount them on anything stronger than the album pages. Use double-sided or transfer tape, applied to the back of each print. Small prints can be held steady on a paper mounting page with a piece of double-sided tape at each corner. Larger prints may need the tape extended along the whole border. You can also use the small paper mounting corners offered for album use.

Prints to be framed must either be mounted on stiff mounting board or be placed in a matte "sandwich" that usually consists of: Backing board, backing matte board, the color print, a top matte (with window cut out to show desired section of the print), glass. You can choose regular glass, or, for slightly more money, a no-glare type.

Color prints do not need to be put behind a top matte, nor do they have to be behind glass. The top cut-out matte serves to put the print in a pleasant setting and to keep the print surface from pressing against a glass cover.

Index